IMAGES
of America

SANTA CLARA

IMAGES
of America

SANTA CLARA

Bea Lichtenstein

ARCADIA
PUBLISHING

CONTENTS

ACKNOWLEDGMENTS

The book evolved over a number of years. In 1984 I began gathering information on Santa Clara and its history. My first source of material and assistance was the City of Santa Clara Public Library. Over the years, generous access materials plus additional assistance was provided by librarians Sylvia Taylor, Anne Skylensky, and Mary Hanel.

The Santa Clara Unified School District allowed me unlimited access to the school board minutes, records, and historic photo archives. A special thanks to Don Callejon for his help over the years.

As I began to gather photographs and needed copies for my files, I enlisted the help of Santa Clara commercial photographer Michael Kohl, who generously donated his services.

Other early volunteers included Lois Weldon and Lynn Harper, who typed several chapters while I continued my research, as well as Ralph Butterworth, Barbara Dahl, and Bob Drews; each provided expertise in areas ranging from graphic design and photo reproduction to editorial development.

This publication would not exist without the following people and organizations who shared photographs and illustrations:

Malcom Margolin, Heydey Books
Estate of Clyde Arbuckle
Santa Clara University Archives
California History Center, DeAnza College
Louise Stagnitto/St. Justin's Church
City of Santa Clara Archives
Santa Clara Public Library
Mary Certa/Charles D. South family
Santa Clara Woman's Club
Intel Corporation
National Semiconductor
Santa Clara Chamber of Commerce
Rotary Club of Santa Clara
Optimist Club of Santa Clara
Leland Kirk/Odd Fellows
The Wilson family
Elayne Franck
South Bay Historical Railroad Society

Mark G. Hylkema
Judge Mark Thomas
Warburton Family
Cunha Family
The Kenyon/Silva Family
Hart Rumbolz
Charles Tucker
Paul Becker
Mrs. Irene Inman
Mark Robinson
Leonard McKay
Heintz Family
Larry Marsalli
Lydia Corea
Marie Heiner
Eugene Acronico
Mary (Anthony) Pascoe

A special thanks to my family and friends, especially my husband, Ken, who endured many hours alone as I worked assembling this material.

Finally, a special thanks to my editor, Hannah Clayborn, for her help and support, plus Arcadia Publishing for giving me this opportunity to complete my dream.

6

INTRODUCTION

Santa Clara and Santa Clara Valley represent a tapestry of many patterns and colors with each section stitched by unique people in their own unique time and unique place.

When José María Francisco Ortega first visited the region in 1769, he came to a valley inhabited by Native Americans. The Spanish called them *Los Costanos* or "the Coast People." They were later referred to as the Ohlone. These Native Americans, who had lived in the region for several thousand years, wove the first patch in our tapestry. The Spanish who began colonizing California added a new design.

The Spanish established a string of 22 churches, or missions, which eventually stretched 600 miles along the California coast from San Diego to Sonoma. The eighth of these missions, founded January 12, 1777, was Mission Santa Clara, named for Saint Clare of Assisi, Italy.

Mexican independence from Spain in 1821 brought Mexican rule that added another section to our tapestry. The change of government had no initial effect on the operation of the missions. The Native Americans still came to the mission for compulsory baptism and conversion to Christianity. By December 1828, there were 8,279 baptisms, 2,376 marriages, and 6,408 deaths at Mission Santa Clara.

In 1836 the founding Franciscan fathers lost control of Mission Santa Clara through the process of secularization. Civil commissioners were to oversee the return of the land to the native population. This did not happen and squatters took over the church buildings and lands. Disorder and decay ensued. By 1839, only 300 natives remained near Mission Santa Clara.

During this period, the Mexican government issued land grants to various favored people. Vast *ranchos* (ranches) appeared and large herds of cattle roamed at will over the land. Hides and tallow comprised the first commercial export products and industry in the area.

In the 1840s, the American frontier expanded west to California and new settlers arrived in the area. After the Mexican-American War, the raising of the American flag over Monterey in July 1846 symbolized that control of California had passed to the United States. California became a state in 1850.

The discovery of gold in 1848 brought a huge influx of people lured by the prospect of wealth. The newcomers added another section to the valley's tapestry. During the Gold Rush the promise of great wealth failed to happen for most gold seekers, so they turned to the "black gold" that was the fertile soil of Santa Clara Valley and settled in Santa Clara to begin a new life.

Santa Clara's place on the tapestry formed in the 1850s, when it began to take shape as a small town. William Campbell performed a survey that laid out the town site into lots of 300 square feet. Each citizen received one lot with the understanding that a house must be built on it within three months or it would go to someone else. A school house, several Protestant churches, hotels, and stores were erected. In 1850 Peleg Rush had 23 "pre-fabricated" homes imported from Boston and shipped around Cape Horn to be put on lots in Santa Clara.

Established on the old mission site in 1851, Santa Clara College became a prominent feature of the developing locale. Santa Clara incorporated as a town in 1852 and became state chartered in 1862. By this time the town covered an area two miles long by one-and-a-half miles wide.

Outside the town limits, small family farms and orchards developed and thrived as testimony to the area's good soil and mild climate.

As the town grew, Santa Clara's economic base began to emerge. In 1865, California pioneer James Lick built a four-story, water-powered flour mill on a 200-acre tract of land along the west bank of the Guadalupe River. In 1866, Jacob Eberhard bought the Santa Clara Tannery (later known as Eberhard Tannery), which became the largest tannery in California. Enterprise Mill & Lumber Company re-organized as Pacific Manufacturing in 1880.

Santa Clara played an important role in the fruit industry that emerged from the orchards of Santa Clara Valley. Levi Ames Gould, a Santa Clara orchardist, shipped California's first carload of fresh fruit east, shortly after the completion of the transcontinental railroad in 1869. Abram Block took over Gould's orchard in 1878 and established A. Block Fruit Company, which became one of the largest deciduous fruit houses in the world.

Other factors that played a role in building the town of Santa Clara included the early development of the rail system that carried the goods produced in Santa Clara to the market; the emergence of the seed industry, which was best symbolized by the C.C. Morse Seed Company; and the continued development in the early 1900s of fruit processors such as the Cured Fruit Association, Rosenberg Bros. Packing, Pratt-Low Preserving Company, and Diana Fruit Preserving.

As the 19th century came to a close, the population increased as more people arrived seeking the mild climate and job opportunities of the Santa Clara area. By 1906 the population of the city had grown to nearly 5,000, and remained fairly stable until after World War II, when Santa Clara outgrew its 19th-century boundaries and expanded to open lands north and west of the original city limits. The family farms and orchards began to disappear as housing was built to accommodate the burgeoning population. By the late 1980s, the city covered 19.1 square miles and the population had grown to 89,000.

The growing population affected many facets of life, including the need for housing and the need for more and better schools, which all required land. This, plus the change in business from farming to manufacturing, brought about the disappearance of the orchards and farms and the agrarian way of life in "The Valley of Heart's Delight."

The 1950s saw the development of a new product, the semiconductor. The resulting electronics industry, based on the silicon chip, gobbled up remaining orchard land and forever changed the agricultural nature of Santa Clara and Santa Clara Valley.

Intel located in Santa Clara in 1970. Other first generation electronics companies included National Semiconductor, Applied Materials, LSI Logic, and Siliconix. By 1990 there were close to 500 manufacturing plants in the city, producing everything from integrated circuits to mini-computers.

In the new century and millennium, the richness of this tapestry continues to unfold. Just as the Native Americans, Spanish, Mexicans, and early settlers of many ethnicities all contributed their unique patches in this wonderful area we call the Santa Clara Valley, so too will this and succeeding generations weave their own parts into the whole. This story of Santa Clara is about our past, present, and future.

One

EARLY HISTORY

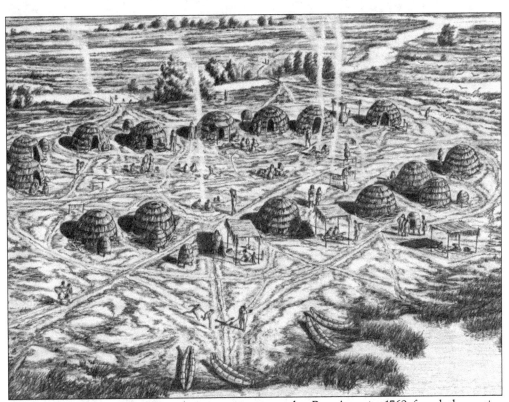

OHLONE VILLAGE. Spanish explorers coming into the Bay Area in 1769 found the native population, later named the Ohlone, living in small groups or tribelets. Michael Harney's reconstruction sketch depicts a typical Ohlone village. Families lived in small, round, dome-shaped dwellings made of bent willow poles covered with mats of tule reeds. A replica of these dwellings can be seen at the deSaisset Museum at Santa Clara University. (Courtesy of Michael Harney from *The Ohlone Way,* © 1978 by Malcolm Margolin.)

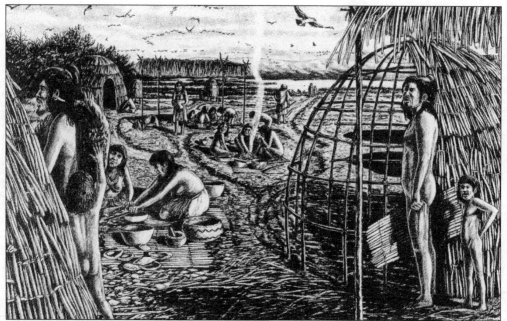

OHLONE FAMILIES AT WORK. Michael Harney's illustration depicts typical Ohlone life with a man working on a dwelling, the women grinding acorns with their mortars and pestles, and another man returning from a hunt with his catch. These indigenous people lived off the land and were hunters and gatherers, rather than tillers of the soil. (Courtesy of Michael Harney from *The Ohlone Way*, © 1978 by Malcolm Margolin.)

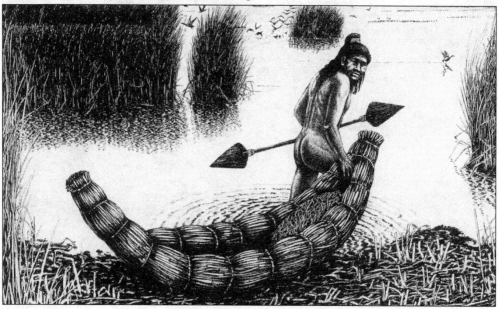

OHLONE TULE BOAT. To aid in catching fish and hunting water fowl, the Ohlones fashioned boats of bundled tule reeds. The boats were about ten feet long and three feet wide in the middle. A double-bladed paddle was used to maneuver the boat. Another food source came from the abundant mussels, clams, and other shellfish dug up from the shore. (Courtesy of Michael Harney from *The Ohlone Way*, © 1978 by Malcolm Margolin.)

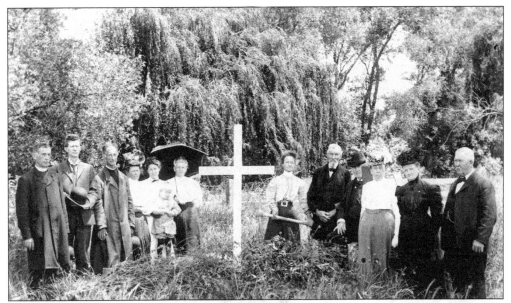

FIRST SITE COMMEMORATIVE CROSS. In April 1907, members of the Santa Clara County Historical Society placed a cross commemorating the first mission site near the confluence of Mission Creek and the Guadalupe River. The plaque on the transept reads, "Monument site First Santa Clara Mission January 12, 1777." (Courtesy Library of Congress Prints and Photo Division, Santa Clara County Files.)

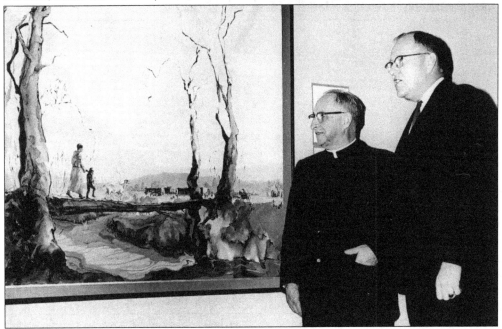

THE SPANISH BRIDGE. Arthur D. Spearman, S.J., and Santa Clara historian Austen D. Warburton view Grace Runcie's historic painting depicting the old Spanish Bridge over the Guadalupe River at the first site of Mission Santa Clara. Fr. Spearman. wrote the book, *The Five Franciscan Churches*, which details the story of the five sites and structures of Mission Santa Clara. (Courtesy of Bernice Cox and Santa Clara Woman's Club.)

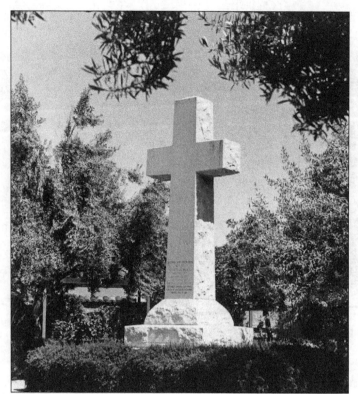

SECOND MISSION GRANITE MARKER. In 1779 the Guadalupe River overflowed, destroying the first mission compound. A temporary mission compound was built on higher ground some 2,700 feet south, while the mission priests looked for a permanent site farther from the river. This granite cross at De La Cruz Boulevard and Martin Avenue marks the second temporary site. (Courtesy of City of Santa Clara Photo Collection.)

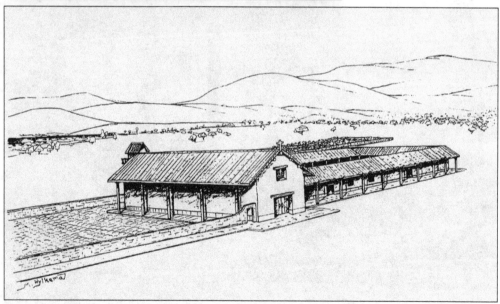

THIRD MISSION CHURCH. Archeologist Mark G. Hylkema has created a reconstruction sketch of the third mission church that is based on his archeological findings of the foundation alignments and historical records. The Native-American cemetery is within the walled area to the left of the church, a walled pear orchard is in the background, and the mission quadrangle is to the right of the church. The view is to the southeast with Mount Hamilton in the background (upper right). (Courtesy of Mark G. Hylkema.)

THIRD MISSION CHURCH CORNERSTONE. On November 11, 1781, Fr. Junipero Serra blessed and laid a cornerstone for the third mission church. Placed in the cavity was a metal cross, two religious medallions, and Spanish coins that signified the church treasury. This cornerstone is displayed at the deSaisset Museum at Santa Clara University. (Courtesy of Santa Clara University Archives.)

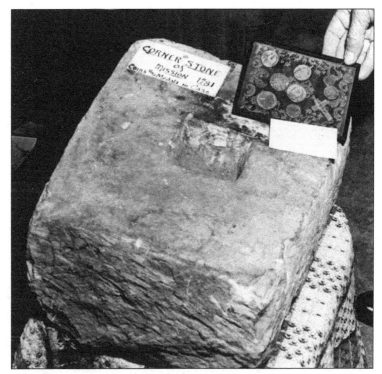

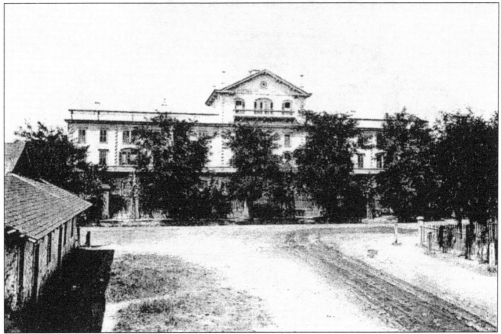

FOURTH CHURCH. After earthquakes in 1812 and 1818 damaged the third church, the church was relocated again. The small adobe structure on the left served from 1819 to 1825 as the fourth interim church, while the fifth Franciscan church was being built. Between 1825 and 1836 the building served to house the Native-American boys. After secularization in 1836, it later became a dance hall. (Courtesy of Santa Clara Woman's Club Archives.)

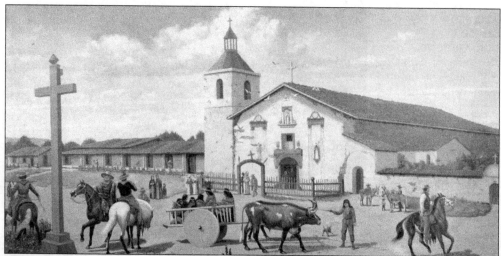

FIFTH MISSION CHURCH. Construction of a new, permanent mission church and compound at the fifth and final site began in 1822. The dedication took place in 1825. This Andrew P. Hill painting depicts the church as it may have looked in 1849, with the horsemen, ox-drawn *carreta*, and worshipers in front of the mission church. (Courtesy of Santa Clara University Archives.)

FIFTH CHURCH AND THE ALAMEDA. In 1799, Fr. Magín Catalá and 200 Native Americans laid out and planted willow trees along a road they named The Alameda. The road made it easier for settlers of Pueblo San José to attend religious services at the mission church. The painting hangs on the second floor of the Orradre Library at Santa Clara University and at the Santa Clara Historic Museum in the Headen-Inman House. (Courtesy of Santa Clara University Archives.)

CALIFORNIO HORSEMEN. Horsemanship and skill in the use of the lasso were qualities highly esteemed by the *Californios*, who were trained from childhood to a life in the saddle. These skills were also utilized during the annual rodeo or round-up of the Mexican/*Californio* era. Cattle were driven in from miles around to one *rancho* where they were separated according to each rancher's brand and then earmarked. (Courtesy of *Historias: The Spanish Heritage of Santa Clara Valley*, California History Center, DeAnza College.)

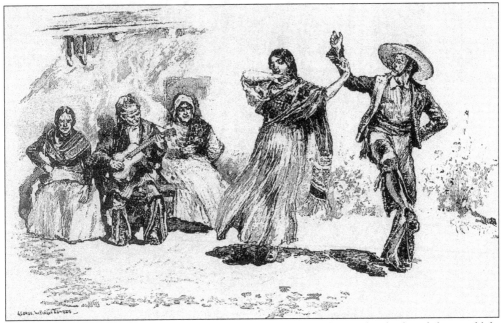

THE FANDANGO. The *Californios* were a gracious and hospitable people who loved the good life, frequent parties, music, and *fandangos* (dances). They would come for miles around since the *ranchos* were so large and far apart. These social gatherings would often last two or three days or more. (Courtesy of *Historias: The Spanish Heritage of Santa Clara Valley*, California History Center, DeAnza College.)

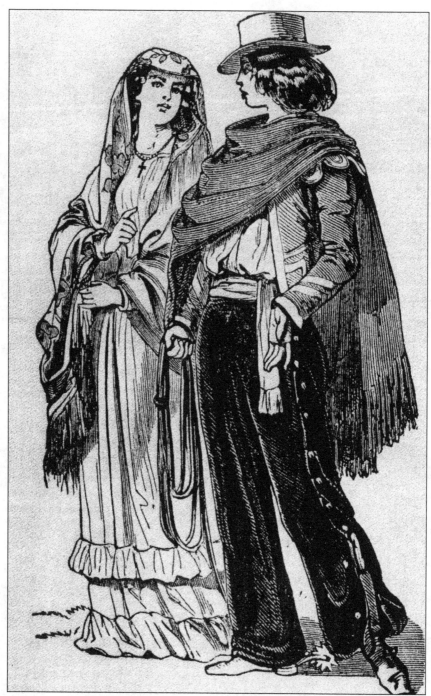

CALIFORNIO CLOTHING. Women of the period typically wore plain-colored calico dresses with long, narrow shawls on their heads or around the shoulders for everyday, and fancier garb for special occasions. The men wore cotton shirts and pants, and *calzoneras,* which were decorated with metal buttons down the sides and worn over the pants. A short jacket, a sash wrapped around the waist, a serape, and a hat completed the ensemble. (Courtesy of *Hutching Illustrated Magazine,* 1856.)

Two

BUILDING THE TOWN

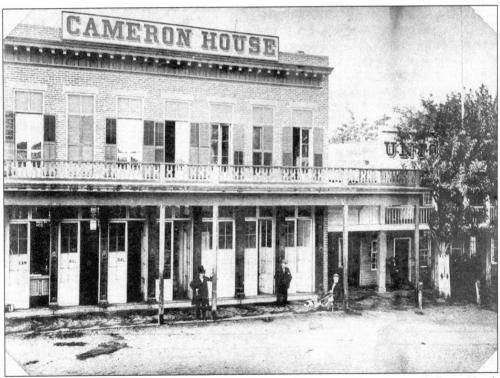

CAMERON HOUSE AND UNION HOTEL. The Cameron House and the adjoining Union Hotel, located on the southeast corner of Franklin and Main Streets, were both owned by John Cameron and originally operated by Appleton and Ainsley. Traveling actors performing at Widney Hall Theater stayed at the Cameron House. Santa Clara's first volunteer fire company, the Tiger Engine Company No. 1, was formed at the Union Hotel in 1855. (Courtesy of Santa Clara City Library, Clyde Arbuckle Collection.)

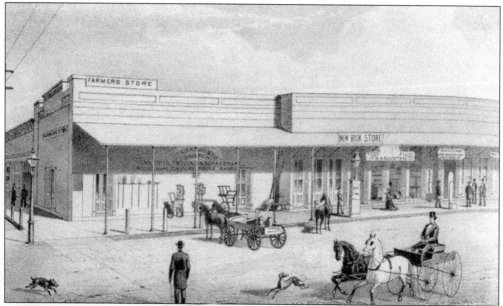

THE FARMER'S STORE. Antonio Fatjo and José Arques established the Farmer's Store at the corner of Franklin and Main Streets in 1849. Later known as John Fatjo and Son, the store provided a wide variety of goods to Santa Clara residents. Members of the Fatjo family continued to operate the store for many decades. (Illustration from *Thompson and West's Historical Atlas*, 1876.)

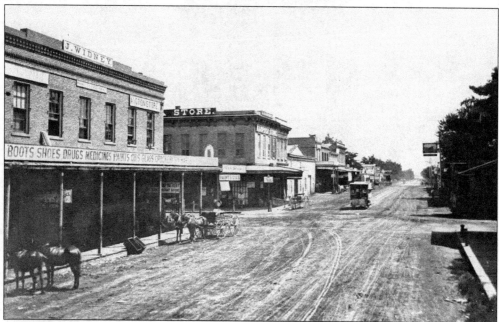

WIDNEY'S MERCANTILE. John Widney (1837–1925) was an early settler in Santa Clara. He opened his store, on the corner of Franklin and Main Streets, in 1857 and continued to operate the business for 30 years until he retired from mercantile life and engaged in real estate enterprises. Widney served as the first treasurer of the City of Santa Clara when its government was formed in 1852. (Courtesy of Santa Clara Historic Archives.)

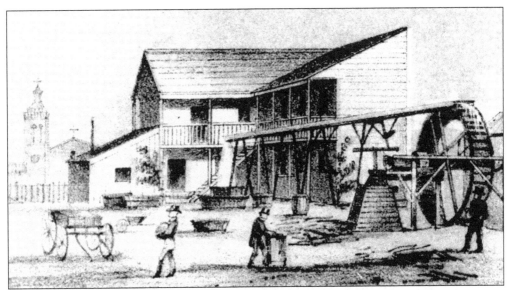

ARGUELLO TANNERY. Sometime during the 1840s, the operation of the old mission tannery was taken over by José Ramon Arguello. The tannery was powered by a large overshot waterwheel turned by the flow of water from the mission *zanza* (canal). The site was later occupied by the Eberhard Tannery. (Kuesel and Dresel lithograph, Santa Clara, 1856; courtesy of Santa Clara Historic Archives.)

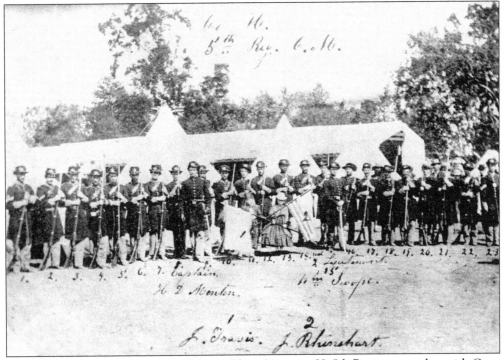

CIVIL WAR UNIT. The members of Santa Clara Company H, 5th Regiment, gather with Capt. H.L. Menton and Lt. William Swope. The children holding flags in the center front are J. Travis and J. Rheinhart. The Santa Clara Tannery supplied leather used in saddles, harnesses, and shoes during the Civil War. (Courtesy of Santa Clara Historic Archives.)

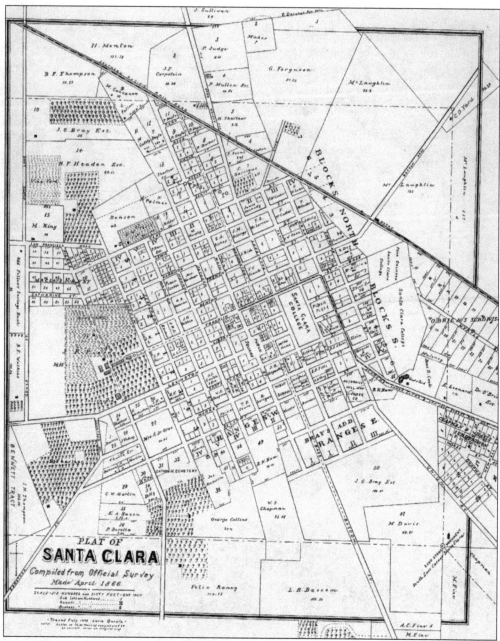

1866 TOWN MAP. This map shows information from a survey done in August 1866, which updated the survey performed by William Campbell in 1847 by adding property owners' names, street names, orchards and vineyards, and other pertinent details. It also shows Santa Clara College and other prominent landmarks. (Illustration from *Thompson and West's Atlas of Santa Clara County, 1876*.)

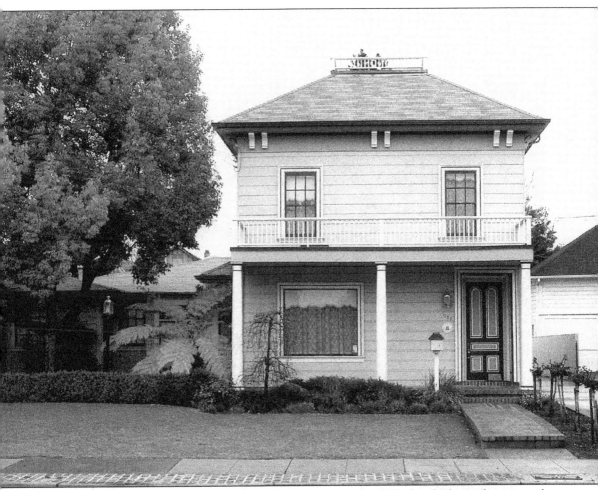

JOHNSON HOUSE. William Campbell performed a survey in 1847 that laid out the town of Santa Clara. The need for frame houses to go on these lots far outnumbered the supply of local building materials. In 1850 Peleg Rush had 23 precut homes shipped around Cape Horn from Boston to Santa Clara. Samuel Johnson, a Santa Clara businessman and civic leader, erected one of the precut "half and half" houses, as they were called, in 1851 at 1159 Main Street. It was subsequently purchased in 1873 by Mary Schumacher, widow of a Civil War colonel. This Italianate structure with a modernized first-floor window still stands today and is a Santa Clara landmark. (Courtesy of Charles Tucker.)

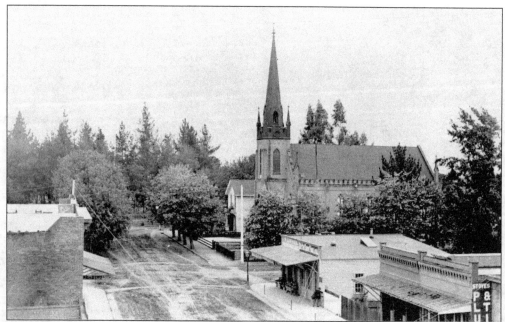

METHODIST EPISCOPAL BRICK CHURCH. The Methodists arrived in Santa Clara in 1846 and built their first church building of adobe brick in 1847. Construction of a second building, a beautiful Gothic-style church with buttressed red brick walls, pinnacles, and a steeple said to be 150 feet high, began in 1862 and was completed in 1867. (Courtesy of Santa Clara Historic Archives.)

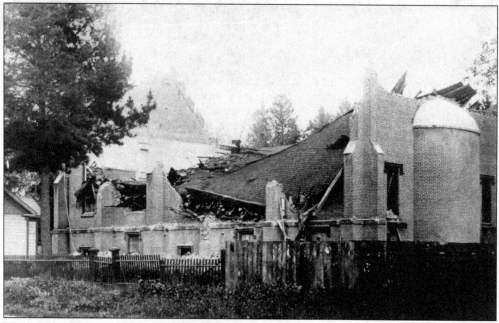

METHODIST BRICK CHURCH 1906 RUINS. The brick Methodist Episcopal Church, located on the corner of Main and Liberty Streets, served the Methodist congregation until April 18, 1906, when the church was demolished by the great San Francisco earthquake. (Courtesy of Santa Clara Historic Archives.)

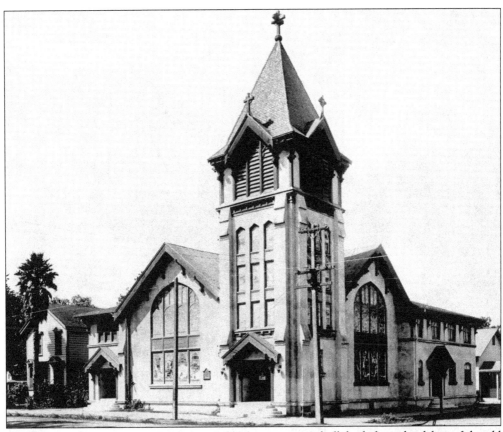

1908 METHODIST CHURCH. By August 7, 1906, a temporary hall, built from the debris of the old brick church, was in use. The foundation of the replacement church was completed on December 3, 1907. The dedication of the new facility took place on October 11, 1908. The beautiful stained glass windows were later incorporated into a new church built in 1965 on Lincoln Street across from Santa Clara's civic center. (Courtesy of Santa Clara Historic Archives.)

ELIM CHURCH. This is the only Gothic-style church in Santa Clara. Originally organized in 1851 as the Advent Christian Church, this building was erected in 1904 and is now located on the corner of Homestead and Monroe Streets. Today, the church serves as the German Elim Assembly of God. The church has changed ownership and is now called Our Mother of Perpetual Help Traditional Catholic Chapel. (Courtesy of City of Santa Clara Photograph Collection.)

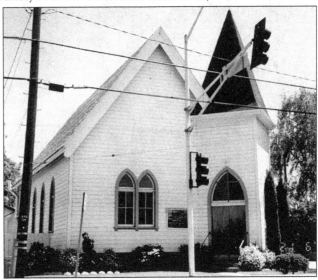

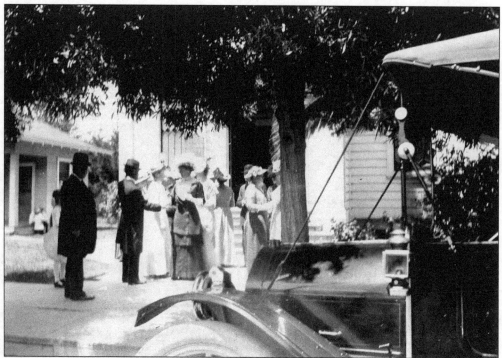

PRESBYTERIAN CHURCH. The Presbyterian church organized in Santa Clara on November 11, 1863, and erected their church building at 1297 Benton Street near the corner of Monroe Street. Standing in front of the church, from left to right, are Judge J.C. Morrison, Rev. J. Falconer, Mrs. Gussie Glendening, and May Morrison. The 1912 Overland on the right was owned by Hubert Bearce. (Courtesy of Santa Clara Historical Archives.)

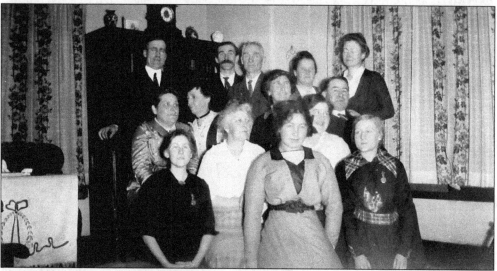

PRESBYTERIAN CHURCH CHOIR. The Presbyterian Church choir, meeting at the home of Hubert Bearce, included, from left to right, (front row) Emily Scott, Mrs. Bearce, Ruth Pogue, Maria Pickett, and Esther Scott; (middle row) Mrs. Raymond, May Morrison, Mrs. Rich, and Will Raymond; (back row) Rev. J. Falconer, Mr. Rich, Ed O'Neill, Mrs. O'Neill, and Mrs. Falconer. (Courtesy of Santa Clara Historical Archives.)

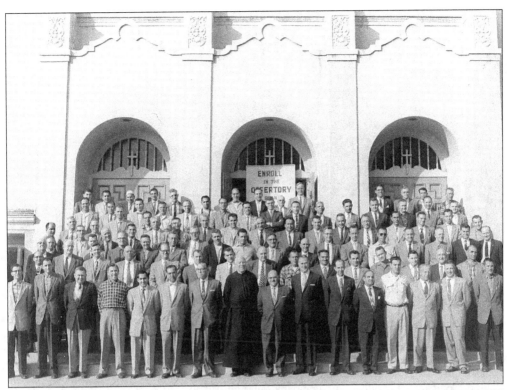

ST. CLARE'S MEN'S GROUP.
St. Clare's Church was dedicated as a parish church on August 26, 1926. Father Maginnis and his devoted men's group pose in front of the church in 1958, before hitting the streets to collect St. Clare Parish pledges. (Courtesy of Cunha family.)

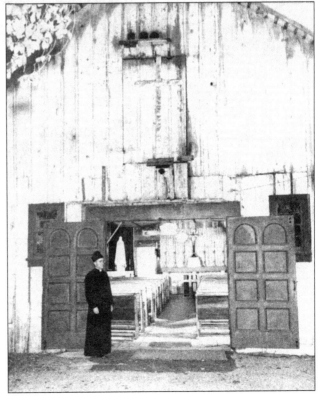

ST. JUSTIN'S STABLE CHURCH.
In the fall of 1951, St. Justin Parish was established. After a lengthy search for a building to serve as a temporary church, all that could be found was a 75-year-old stable. Through donations and the help of many, a transformation took place, and St. Justin's celebrated its first mass on October 28, 1951. The stable church served until the opening of the new Homestead Road Church on November 4, 1956. (Courtesy of St. Justin's Church Archives.)

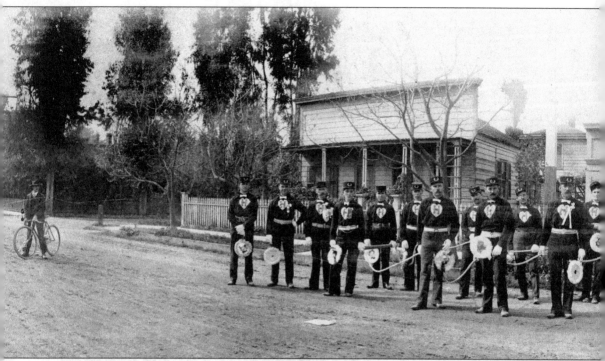

HOPE HOSE COMPANY AND CART. The Hope Hose Company formed in 1881 after the Columbian Engine Company disbanded. The company building was located at 920 Washington between

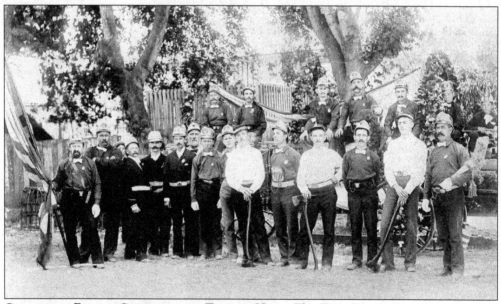

COLUMBIAN ENGINE COMPANY AND TANNER HOSE. The Tiger Engine Company, organized in 1855, became the Columbian Engine Company No. 1 in 1856. The uniform of this company consisted of a red shirt, black pants, blue cap trimmed with red and black patent leather front piece, a black belt with gold lettering, and a metal badge worn over the left breast. The men on the left, with jackets, are from the Tanner Hose Company. (Courtesy of Santa Clara Historic Archives.)

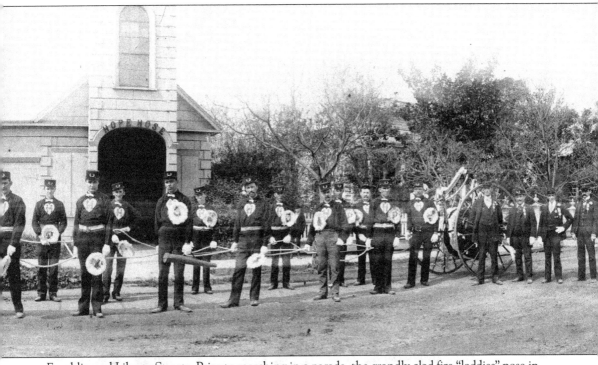

Franklin and Liberty Streets. Prior to marching in a parade, the grandly clad fire "laddies" pose in front of their building with their hose cart. (Courtesy of Santa Clara Historic Archives.)

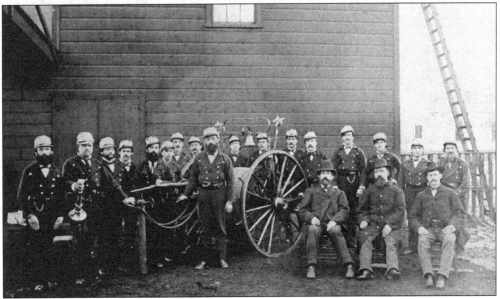

TANNER HOSE COMPANY In 1878 the employees of the Santa Clara Tannery, later called Eberhard Tannery, organized the Tanner Hose Company. Tannery owner Jacob Eberhard bought the hose cart and 500 feet of hose, originally intended for use in the tannery only. Tanner Hose became one of the five companies that formed Santa Clara's volunteer fire department. (Courtesy of Santa Clara Historic Archives.)

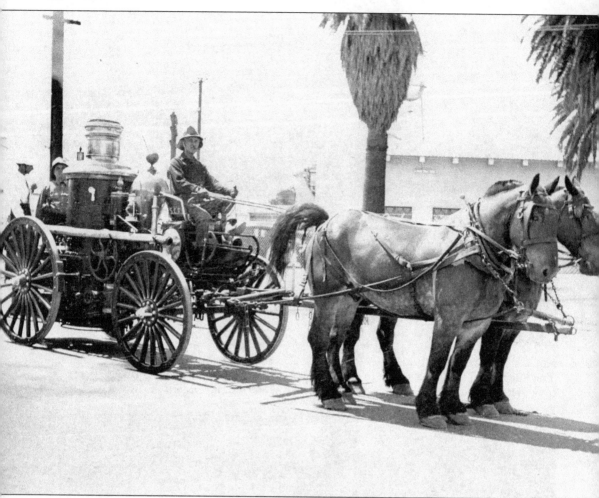

HORSE-DRAWN STEAM ENGINE. As buildings grew taller, hand-operated pumpers proved ineffective in propelling water high enough to reach the flames. The next step was steam-operated pumpers whose heavy weight required horsepower to pull them. (Courtesy of Santa Clara Historic Archives.)

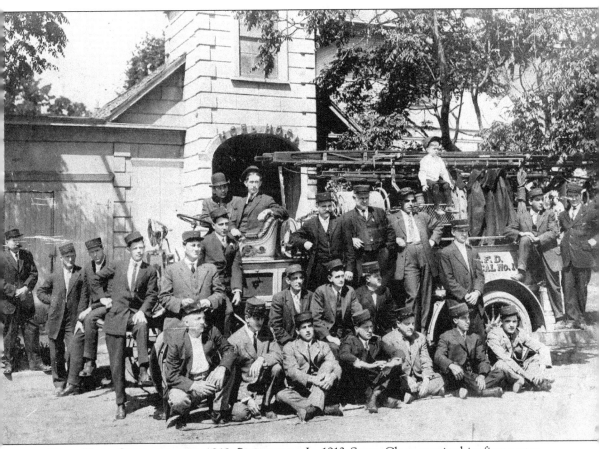

HOPE HOSE COMPANY AND 1913 SEAGRAVES. In 1913 Santa Clara acquired its first motor-driven fire engine, a chemical wagon, from the Seagraves Company for $5,500. Hope Hose Company volunteers posing with the Seagraves in front of their engine building, from left to right, include the following: (seated on the ground) Dick Kifer, Oscar Durell, Emil Biagini, Martin Miller, Barry Moriarty, and Shorty Periera; (seated on the running board) Bill Loos, Rick White, and Joe Scanlan; (standing on the running board) Joe Robidoux, Chickeets Carrea, Pete Ramon, and Charlie Haight; (standing in the street on the left) Tim Malone, Bill Condon, Ally Sallows, unidentified, and Jack Venegas; (on the seat) Frank Menzel and Dave Walsh. The boy (standing at top) and the man (on the tailboard on the right) are not identified. (Courtesy of Santa Clara Historic Archives.)

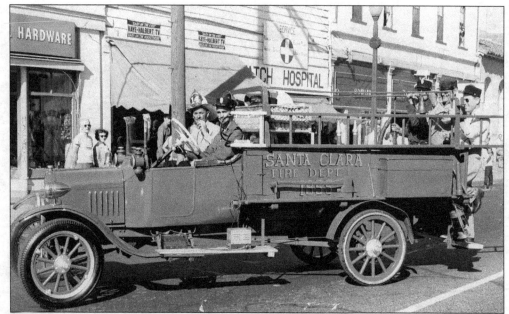

MODEL T HOOK AND LADDER. In 1921 the town purchased its second piece of motor-driven apparatus, a Ford Model-T hook and ladder truck. This equipment was used to fight an oil fire at Eberhard Tannery on July 10, 1935, and again on October 11, 1937 to fight the fire that destroyed the Baptist church (originally the Presbyterian church) on Benton Street. (Courtesy of Santa Clara Historic Archives.)

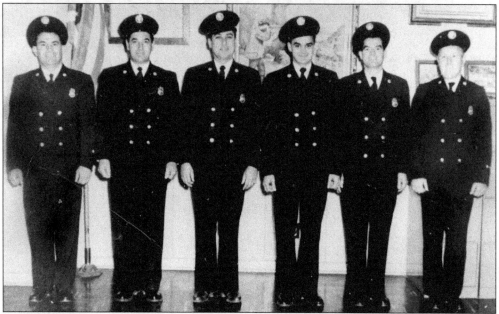

FIRST PAID FIREFIGHTERS. A milestone came in 1949 with the hiring of the city's first paid professional fire fighting force. These six "pioneers" included, from left to right, Jess Rogers, John Andrade, Leonard George, Emil Flosi, Frank Toledo, and George Koop. The original five volunteer companies remained intact to support the paid fire professionals when the need arose. (Courtesy of Santa Clara Photograph Collection.)

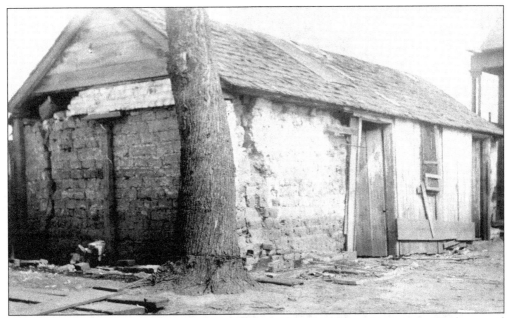

ADOBE JAIL. This adobe jail was built in the late 18th century, at the corner of Jackson and Harrison Streets. Prisoners were handcuffed to heavy iron rings in the floor. Its use as a jail was discontinued in 1846 and the structure became a storeroom and wood shed. The jail was demolished in 1922, but not before local newspaperman Peter J. Riley took the only known photo of the relic. (Courtesy of Santa Clara Woman's Club Archives.)

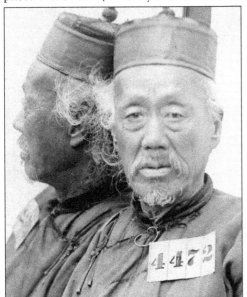

MUG SHOTS. Prisoners booked for crimes in Santa Clara were photographed as part of the booking process. Note the use of a mirror to get front and side shots in one photograph. One wonders what "crime" the woman committed. The Chinese gentleman was referred to as a "Chinaman" in the booking record. Santa Clara and the surrounding area had a large number of Chinese workers who were brought in to work as farm laborers. (Courtesy of Santa Clara Historic Archives.)

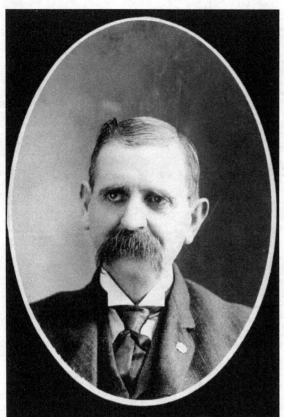

NIGHTWATCHMAN GEORGE WHYBARK. The position of nightwatchman (equivalent to the modern day patrolman) was created to assist the town marshal. Nightwatchman George Whybark was killed in the line of duty on March 14, 1910, as he encountered a prowler at Leibe's Saloon on the corner of Franklin and Alviso Streets. (Courtesy of Santa Clara City Library, Clyde Arbuckle Collection.)

MOTORCYCLE TRAFFIC OFFICERS. Santa Clara hired its first traffic officer, Mayo Dugdell, in 1924. Marshal John O'Neill is shown with, from left to right, motorcycle officers Clarance Andrade and Manuel Sylvia, and Inspector Frank Sapena, about 1948. The T&D Garage in the background served to house volunteer firefighters until 1949 when the paid firefighters took possession of the first city firehouse at Main and Benton Streets. (Courtesy of Santa Clara Historic Archives.)

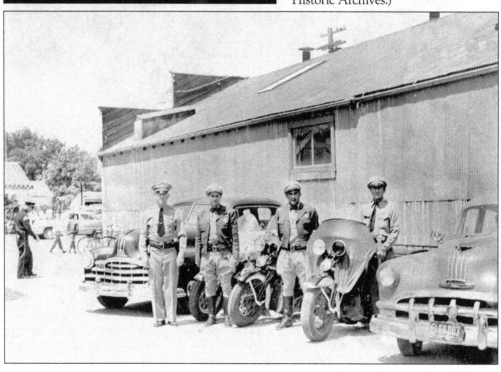

JUSTICES OF THE PEACE. Irving W. Herrington (1859–1908), a Santa Clara native and the son of prominent local attorney Dennis W. Herrington, served as Justice of the Peace from 1884 to 1906. James E. Glendenning (1855–1921), a Santa Clara native, served as Justice of the Peace from 1903 to 1921. Glendenning first heard cases in the 1891 city hall at Main and Benton Streets and later in the 1913 city hall. (Courtesy of Judge Mark Thomas.)

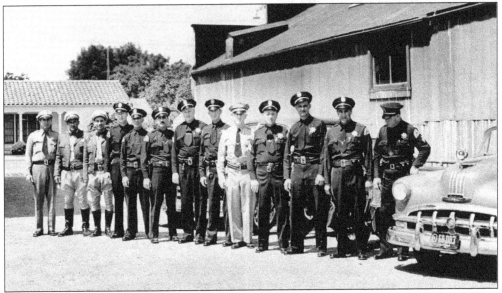

SANTA CLARA POLICE FORCE. Santa Clara law enforcement grew from one marshal in 1852 to a full-fledged police department that by 1919 included a police chief, assistant police chief, an inspector (detective), three patrol sergeants and one traffic sergeant, plus seven patrolmen and a traffic patrolman. (Courtesy of Santa Clara Historic Archives.)

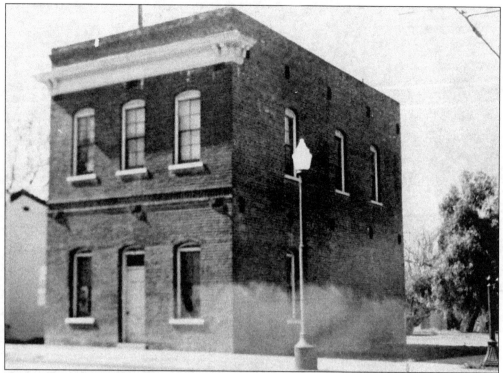

FIRST CITY HALL AND JAIL. The first city hall was built in 1891 at the corner of Main and Benton Streets. The two-story brick structure housed city government functions and a court facility. Access to the second floor was by means of an outside stairway on the left side of the building. It also housed the jail on the first floor at the rear of the building. (Courtesy of Santa Clara Historic Archives.)

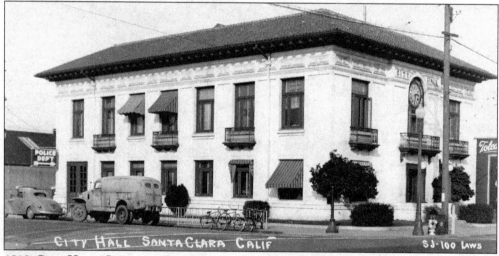

1913 CITY HALL, JAIL, AND LIBRARY. By 1913, the 1891 town hall on the corner of Main and Benton Streets had become inadequate. A new facility was built at the corner of Franklin and Washington Streets. This two-story Spanish Colonial Revival–style building housed city government functions, the marshal's office, a courtroom, the jail (at the rear of the building), and the first city library on the second floor. (Courtesy of Santa Clara Historic Archives.)

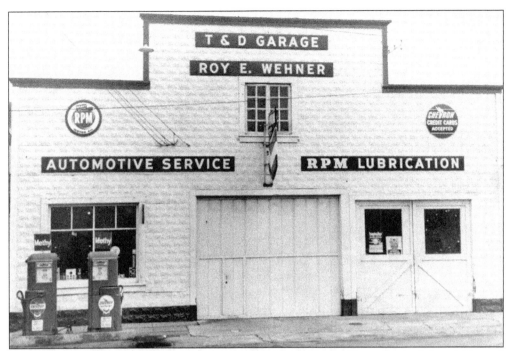

T&D GARAGE. The T&D Garage at 1049 Washington Street (formerly the Menzel Garage) served to house volunteer firefighters who slept in the garage loft. There was no fire pole to slide down, however. Henry and Frank Menzel owned the original garage and were themselves members of the volunteer fire department. Henry, a master plumber, served as fire chief from 1910 to 1912. (Courtesy of Santa Clara Historic Archives.)

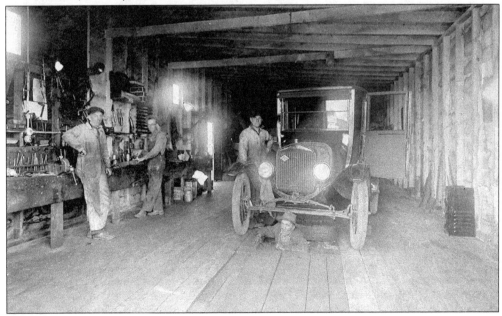

MEN IN GARAGE. The mechanics in this old-time garage work on an early model automobile. Note the wooden floor and the pit, which provided access to work under the car before the advent of mechanical hoists. (Courtesy of Santa Clara Historic Archives.)

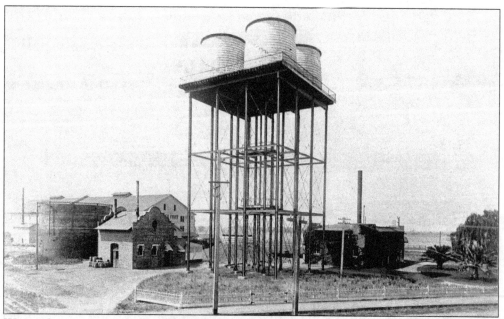

WATER STORAGE TANKS. Water from four 225-foot-deep wells was pumped simultaneously into the water mains and into four 45,000-gallon redwood tanks on an 80-foot steel tower. These tanks were the town's only water supply storage. (Courtesy of Santa Clara Historic Archives.)

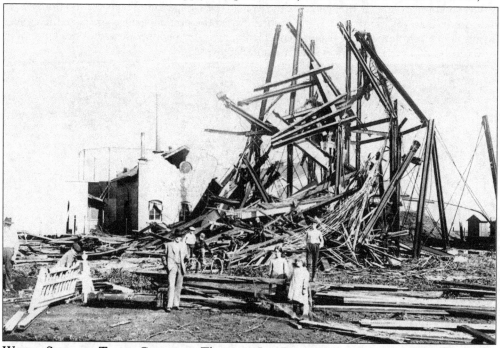

WATER STORAGE TANKS COLLAPSE. The great San Francisco Earthquake on April 18, 1906, did much damage to a wide radius, including the area in and around Santa Clara. The water storage tanks collapsed, leaving the town without any storage capability. Subsequently, the town built both a cistern and a 100,000-gallon elevated tank, which combined held 2 million gallons of water. (Courtesy of Santa Clara Historic Archives.)

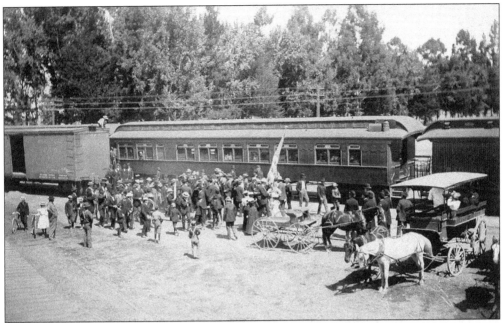

PASSENGERS DEBARK AT SANTA CLARA DEPOT, C. 1890. The Santa Clara Depot, built in 1864, was an original way station on the San Francisco & San Jose Railroad line (later taken over by Southern Pacific). Initially built on the east side of the tracks, the depot was moved in 1877 to its present location so it would be on the same side of the city and Santa Clara College. (Courtesy of Bea Lichtenstein Collection.)

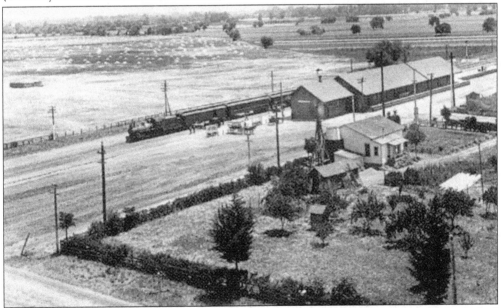

SANTA CLARA TRAIN DEPOT. When the passenger depot was relocated in 1877, it was attached to an existing 30-foot by 60-foot freight warehouse that had been constructed several years earlier. Due to the volume of agricultural products being shipped from Santa Clara at that time, the freight house was increased to its present size of 32 feet by 160 feet. This photo was taken c. 1904. (Courtesy of South Bay Historical Railroad Society Museum.)

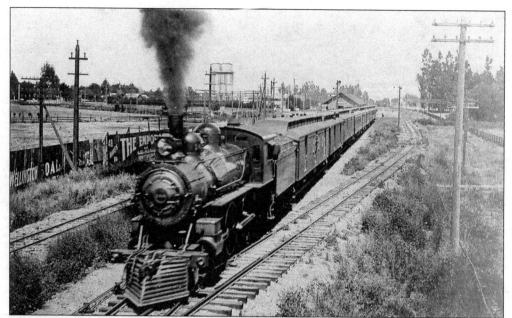

SAN FRANCISCO & SAN JOSE RAILROAD. Looking north, this picture shows a southbound passenger train approaching the crossing where the narrow gauge tracks of the South Pacific Coast Railroad (on the right) and the main standard gauge tracks merged. The Santa Clara depot in the center and the water storage tanks on the left are seen in the background. The sign on the fence says "48 miles to the Emporium" (a department store in San Francisco). (Courtesy of Santa Clara Historic Archives.)

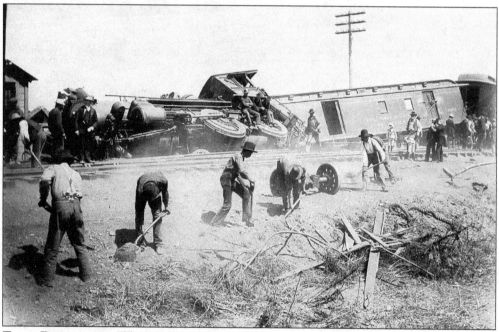

TRAIN DERAILMENT. When the switch was not thrown in time to guide a train onto the proper track, collisions and derailments occurred, creating a great clean-up task for the men shown here. (Courtesy of Bea Lichtenstein Collection.)

Three

EARLY SETTLERS

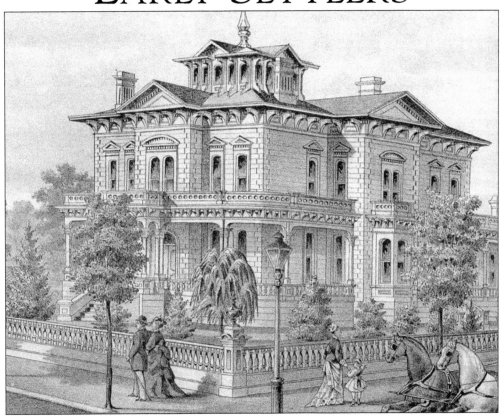

JOSÉ RAMON ARGUELLO HOME. In the 1860s, José Ramon Arguello constructed a beautiful mansion on the northwest corner of Santa Clara and Washington Streets for his wife, Isabel, and their children. His mother, Soledad, also moved in with them, leaving her home on the northeast corner of Santa Clara Street to her son, Luis Antonio (the younger), and his wife, Angela. The Arguello family was noted for its hospitality. (Illustration from *Thompson and West's Historical Atlas*, 1876.)

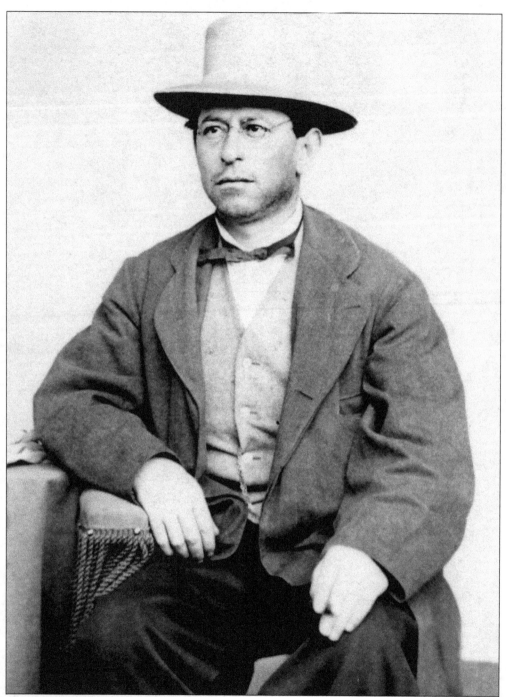

JOSÉ RAMON ARGUELLO. José Ramon Arguello, the son of Luis Antonio (the elder) and Soledad (Ortega) Arguello, was born September 8, 1828, at the San Francisco Presidio. Educated in Monterey, he went into the mercantile business in Mexico City. In 1846 he returned to California to care for family interests on their Rancho Las Pulgas in San Mateo County. He returned to Santa Clara where he lived until his death at age 48, in 1876. (Courtesy of Warburton family.)

LUIS ANTONIO ARGUELLO (THE YOUNGER). Luis Antonio Arguello (1830–1898), the youngest child of Luis Antonio (the elder) and Soledad (Ortega) Arguello, was born four months after the death of his father. Luis Antonio (the younger) is shown on the right with his cousin Ignacio Malarin (on the left). The Malarins and the Fatjos were other relatives who lived on Santa Clara Street, between Main and Washington Streets. (Courtesy of Warburton family.)

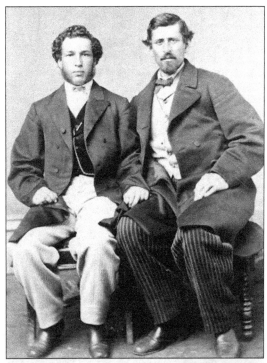

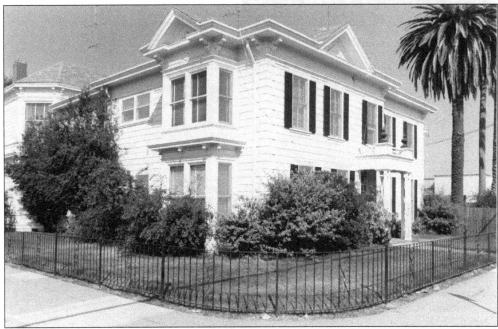

LUIS ANTONIO ARGUELLO (THE YOUNGER) HOME. When Soledad (Ortega) Arguello moved to Santa Clara in 1857, she purchased half a city block on the corner of Santa Clara and Main Streets. Later, Soledad moved to her son José Ramon's mansion, leaving her home to Luis Antonio (the younger) and his wife, Angela. After Soledad's death, Luis Antonio inherited the property which still stands today and is a Santa Clara landmark. (Paul Becker photo; courtesy of City of Santa Clara Photograph Collection.)

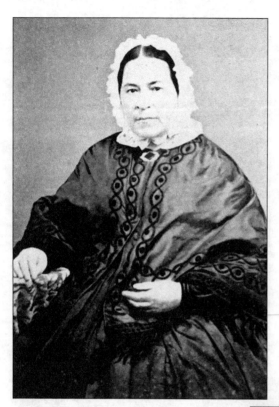

SOLEDAD (ORTEGA) ARGUELLO. Soledad Ortega (1797–1874), who married Luis Antonio Arguello (the elder) on August 30, 1822, at Mission Santa Barbara, was the daughter of José Maria Ortega and Maria Francisa Lopez. José Ortega, known as the "Pathfinder," was part of the 1769 Portola Expedition that discovered San Francisco Bay. (Courtesy of Warburton family.)

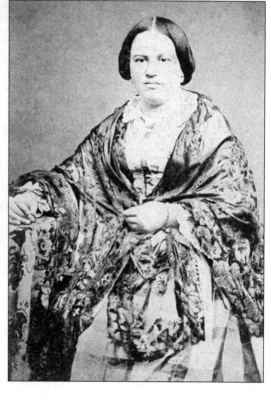

ISABEL (ALVISO) ARGUELLO. Isabel Alviso (1834–1860), the daughter of Anastacio and Maria Antonia (Altamirano) Alviso, married José Ramon Arguello on October 29, 1851, at Mission Santa Clara. Isabel's grandfather, Ygncio Alviso, along with his mother and sister, were members of the 1775–1776 Juan Bautista de Anza Expedition to San Francisco. (Courtesy of Warburton family.)

ANGELA (BERRYESSA) ARGUELLO. Angela Berryessa (b. 1835), the daughter of José Ignacio Berryessa of the New Alamaden Berryessa family, married Luis Antono (the younger) in 1852 at Mission Santa Clara. Most of the Arguello family members are buried in the Arguello plot at Santa Clara Mission Cemetery, as are their Malarin and Fatjo relatives. (Courtesy of Warburton family.)

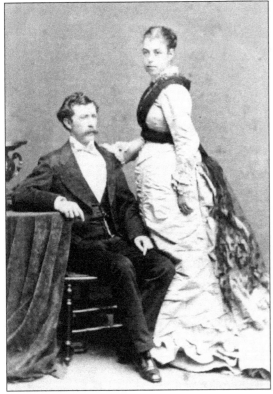

NICHOLAS (THE YOUNGER) AND ISABEL (ARGUELLO) DEN. Isabel Arguello (1855–1942), the daughter of José Ramon and Isabel (Alviso) Arguello, married Nicholas Den (1848–1901), son of Dr. Nicholas and Rafaela (Hill) Den at Mission Santa Barbara, about 1878. Dr. Nicholas Den, from Ireland, and Dr. Henry Warburton, from England, were two of only three practicing physicians in all of Alta California in 1848–49. (Courtesy of Warburton family.)

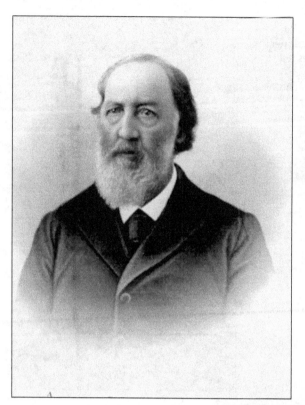

DR. HENRY H. WARBURTON. Dr. Henry Hulme Warburton (1819–1903) came from a long line of physicians in England. He came to America in 1844 and practiced in New York until signing on as surgeon on a whaling ship. Resigning his commission in 1847, Warburton eventually made his way to California and Santa Clara where he became the town's first physician in 1848. (Courtesy of Warburton family.)

CATHERINE PENNELL WARBURTON. Catherine Pennell (née Long) (1829–1905), who had come to California by wagon train, married Dr. Henry H. Warburton in Santa Clara in 1855. The Warburtons raised a family of two daughters and three sons: Caroline (1860–1937), Ellen (1861–1949), John (1862–1950), Charles (1866–1932), and Henry Luke (1869–1947). (Courtesy of Warburton family.)

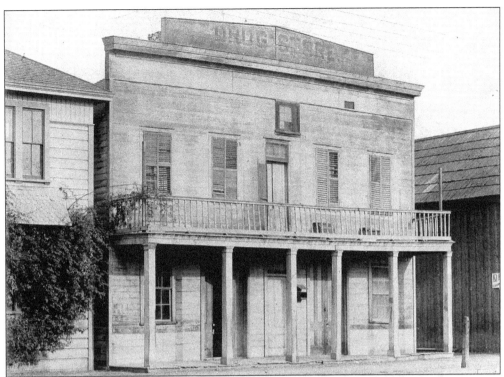

WARBURTON PHARMACY. Dr. Henry Warburton established Santa Clara's first pharmacy around 1860. Located on Main Street, the pharmacy is shown just three days before the building was destroyed on November 4, 1906, by a rapidly spreading fire that started in Josiah Rainey's livery stable. (Courtesy of Santa Clara City Library, Alice Hare Collection.)

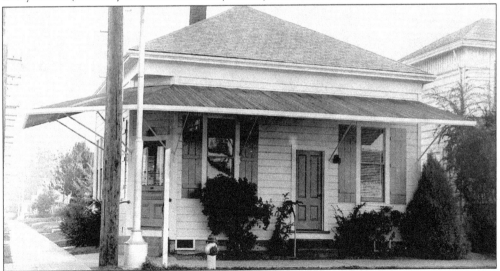

DR. WARBURTON'S OFFICE. The office of Dr. Henry H. Warburton was located on the corner of Main and Benton Streets. After his death, the office was used by Dr. Fowler and then Dr. Gallup. In the 1960s, when the urban renewal project demolished eight square blocks of downtown Santa Clara, Warburton's office was moved to the San Jose Historic Museum and reinstalled as part of its "old town" replica. (Courtesy of Warburton family.)

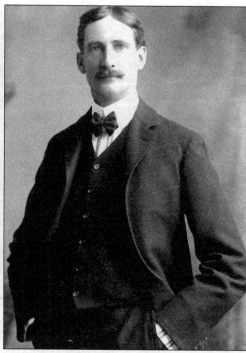

HENRY LUKE AND MARY (DEN) WARBURTON. Henry Luke Warburton (1869–1947), the youngest son of Dr. H.H. and Catherine Warburton, married Mary Den on August 18, 1902. Henry Luke was active in Santa Clara civic affairs and helped organize the Mission Bank in 1910. Mary was a charter member of the Santa Clara Woman's Club, founded in 1904, and played a principal role in the purchase of the Peña Adobe for the Woman's Club to use as a clubhouse. (Courtesy of Warburton family.)

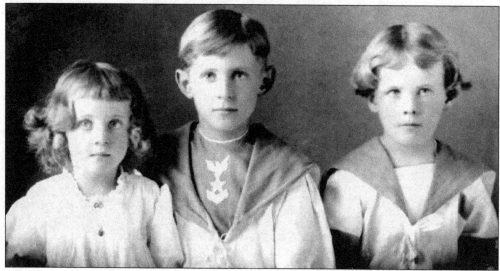

MARIE, LUKE, AND ROLLO WARBURTON. The children of Henry Luke and Mary (Den) Warburton included Marie Ramona (1907–1994), Henry Luke Jr. (1903–1972), and Rollo Pennington (1906–1914). (Courtesy of Warburton family.)

AUSTEN DEN WARBURTON. Austen Den Warburton (1917–1995), the youngest son of Henry Luke and Mary (Den) Warburton, was a life-long resident of Santa Clara. He graduated from San Jose State College and then went to Santa Clara University, where he received his law degree in 1941. For over 50 years he was a practicing attorney and a partner in the law firm of Campbell, Warburton, Britton, Fitzsimmons & Smith. (Courtesy of Warburton family.)

AUSTEN DEN WARBURTON. Austen Warburton, a noted historian and author, was a member of many historical groups as well as a lecturer and tour leader on the history and archeology of California and the Southwest. He is shown here sitting on the headstone of the outlaw Tiburcio Vasquez while giving a tour at Santa Clara Mission Cemetery. (Courtesy of Warburton family.)

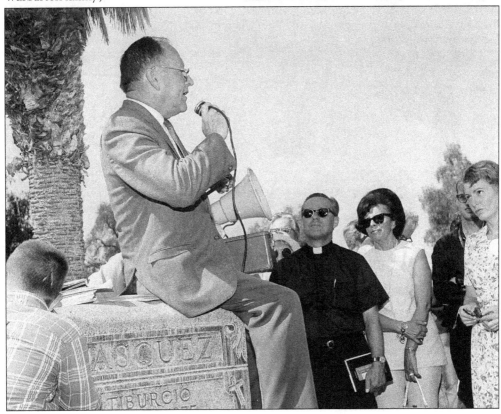

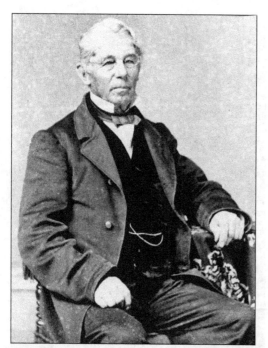
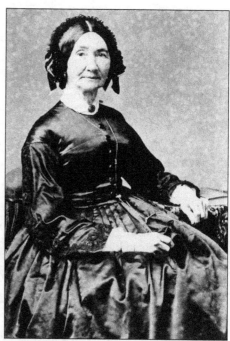

MAJ. JOHN AND THEODORA JANE COOK. Maj. John Cook (1796–1877), born on the Isle of Wight in England, and Theodora Jane Wheeler (1797–1848) were married in England on August 26, 1816. They came to America and settled in Springfield, Ohio, where Theodora died in 1848. Cook came west and settled in Santa Clara in 1851. (Courtesy of Mary Pascoe to Bea Lichtenstein Collection.)

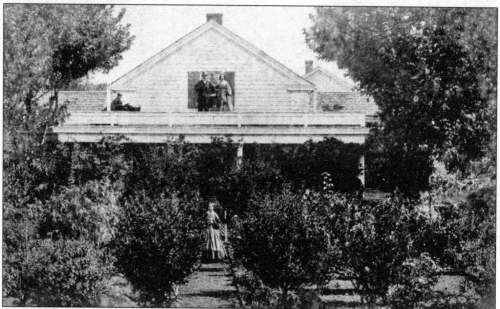

COOK HOUSE. After settling in Santa Clara, Maj. John Cook married Jane B. Fulkerson, born in Nova Scotia in 1809, on March 30, 1851. The Cooks built a house in the summer of 1853 on Deep Springs Lake (later called Cook's Pond) just off The Alameda. (Courtesy of Mary Pascoe to Bea Lichtenstein Collection.)

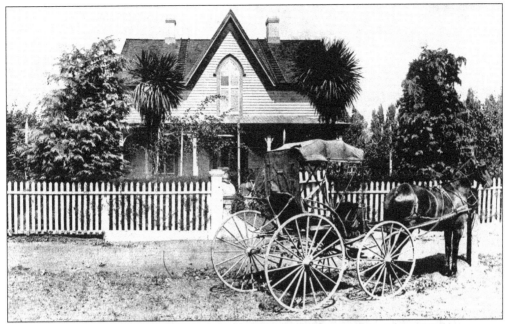

NATHANIEL COOK HOUSE. Nathaniel Cook (1818–1898), born on the Isle of Wight, came to America with his parents and lived in Indiana. Cook married Eliza Jane Hubbell (1827–1911) in Springfield, Ohio, on July 2, 1846. Nathaniel and Eliza came to Santa Clara, where his father already lived, in 1857. They built this lovely Gothic-style house at Lewis and Lafayette Streets. (Courtesy of Mary Pascoe to Bea Lichtenstein Collection.)

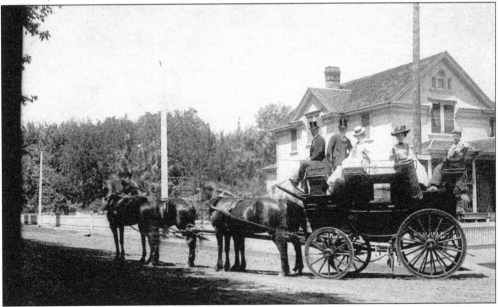

COOK FAMILY AND BUGGY. Nathaniel and Eliza Cook had four sons while living in Springfield, Ohio. A daughter, Mary Jane (Minnie), was born in Santa Clara on February 23, 1860. Minnie married Dr. Francis Keith Saxe on November 22, 1883, in Santa Clara. Their two children, Helen and Arthur, are seated in the rear of this handsome conveyance. (Courtesy of Mary Pascoe to Bea Lichtenstein Collection.)

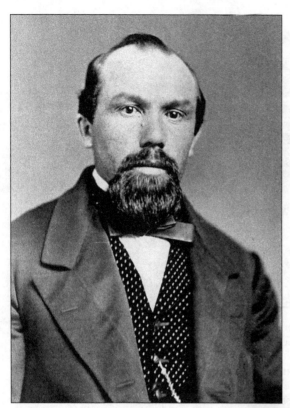

FREDERICK CHRISTIAN FRANCK I.
Frederick Christian Franck I (1828–1902), a native of Germany, settled in Santa Clara in 1855 and quickly became an influential resident, active in community affairs. Appointed fire chief when the first volunteer fire company organized in 1855, he served on the town board of trustees, served two terms in the state legislature in 1871 and 1874, and was elected to the California Senate in 1894. (Courtesy of Elayne Franck to Bea Lichtenstein Collection.)

CAROLINE (DURMEYER) FRANCK.
Caroline Durmeyer (1834–1900),also a native of Germany, married F.C. Franck in Santa Clara on September 23, 1857. The Francks were the parents of eight children, but only two survived to maturity: Caroline (1877–1949), who married Willis A. Laine, and Frederick "Fred" Christian Franck II (1873–1954), who married Maude Shuld. (Courtesy of Elayne Franck to Bea Lichtenstein Collection.)

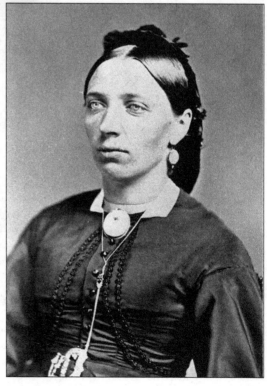

FRANCK MANSION. The Francks built a Queen Anne–style Victorian mansion, designed by Theodore Lenzen, at the corner of Washington and Benton Streets, where the Wells Fargo Bank is presently located. F.C. Franck is shown in front of his home in this photo. After the deaths of Caroline and Frederick Franck, their daughter Caroline inherited the property and lived in the house until her death in 1949. (Courtesy of Santa Clara Historic Archives.)

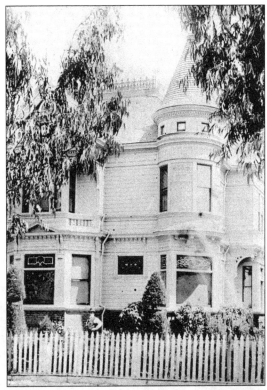

LAYING OUT IN THE FRANCK PARLOR. Frederick Christian Franck I died December 20, 1902 at age 74. As was the custom in those days, the body was displayed in the parlor and funeral services were conducted from the family home. The services were held under the auspices of Santa Clara Odd Fellows Lodge No. 52 and True Fellowship Lodge 238, whose members accompanied the funeral procession to the city cemetery where Franck was laid to rest. (Courtesy of Santa Clara Historic Archives.)

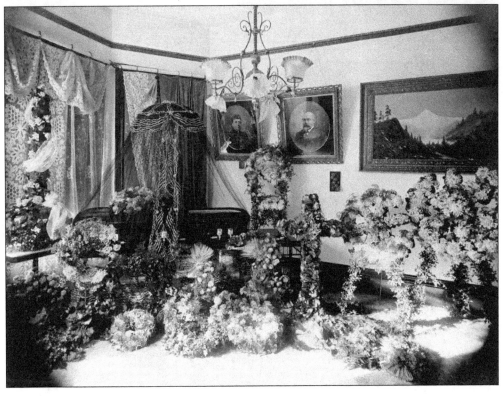

FRED II AND MAUDE (SHULD) FRANCK. On August 16, 1900, Frederick Christian Franck II (1873–1954) married Maude Delilah Shuld (1879–1960) in San Francisco. The couple lived on The Alameda in San Jose until they built their home in Santa Clara on the property left to him by his parents, F.C. and Caroline Franck. (Courtesy of Elayne Franck to Bea Lichtenstein Collection.)

FRANCK II MANSION. Fred and Maude Franck built their Louis Lenzen–designed home in 1905 on land inherited from Fred's father, F.C. Franck. The Colonial Revival–style house had five bedrooms, a parlor, dining room, library, kitchen, and two bathrooms, as well as all the modern conveniences and luxuries of the era, including central heating and combination gas and electric chandeliers. This home has been wonderfully restored and is a Santa Clara landmark. (Courtesy of Bea Lichtenstein Collection.)

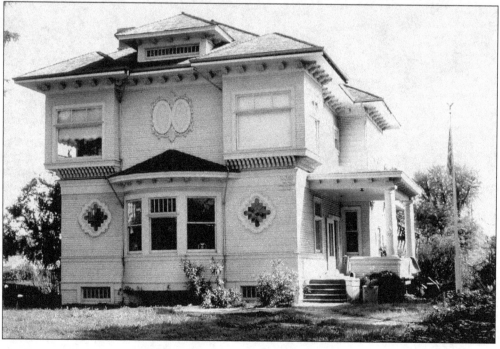

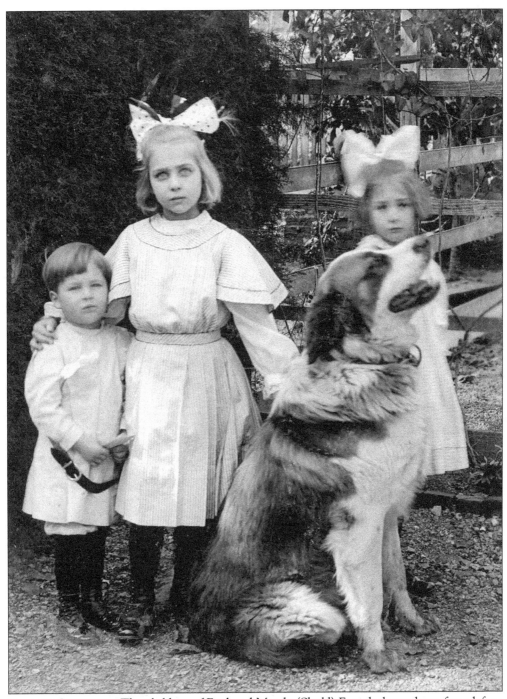

FRANCK CHILDREN. The children of Fred and Maude (Shuld) Franck shown here, from left to right, with their St. Bernard, Buster, are Frederick "Freddie" Christian Franck III (1905–1982), who was born in the new Franck home at 1179 Washington Street; Delilah (1901–1960), born in 1901 in San Jose; and Gladys (1903–1925), born in San Jose and died at age 22 in her bedroom (referred to as the dying room) in the Franck II Mansion. (Courtesy of Elayne Franck to Bea Lichtenstein Collection.)

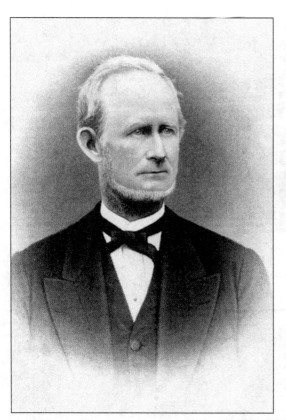

DR. BENJAMIN FRANKLIN HEADEN. Dr. Benjamin Franklin Headen (1813–1875) came by wagon train from Rockville, Indiana, to Santa Clara Valley in 1852 with his second wife, Julia, son George, and two daughters. He bought 61 acres on the outskirts of the Santa Clara township. There, he erected a home and began to improve and cultivate his property, raising first grains, then strawberries and other small fruits, and then later, orchards and vineyards. (Courtesy of Mrs. Irene Inman.)

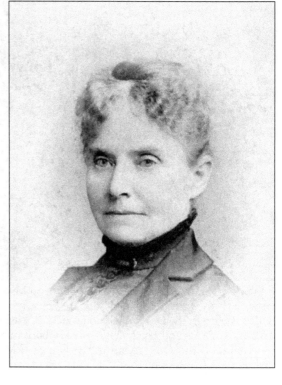

HENRIETTA (JOHNSON) HEADEN. After the death of his wife, Julia, Headen married a third time, in 1859, to a widow, Henrietta (Harvey) Johnson (1868–1897). Three children were born of this union: Henrietta H. (1861–1891), Thomasine (1864–1934), and Benjamin Franklin (1869–1873). Henrietta H. died in childbirth and the child lived about a year. The child's christening dress is displayed at the Headen-Inman Historic Museum. (Courtesy of Mrs. Irene Inman.)

THOMASINE (HEADEN) ALBERTSON.
Thomasine Headen (1864–1934), the
youngest daughter of Dr. Benjamin
Franklin and Henrietta Headen, married
Louis Albertson (1868–1928) in 1901.
Thomasine inherited the Headen
property after her mother, Henrietta, died
in 1897. (Courtesy of Mrs. Irene Inman.)

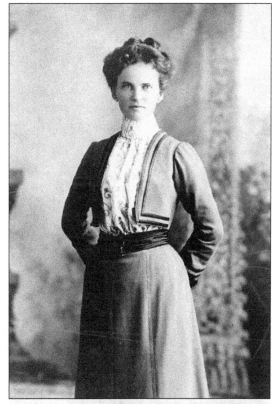

HEADEN HOUSE. The home built by Dr.
B.F. Headen was a splendid homestead,
one of the most beautiful in the valley.
Shown admiring the lovely landscaping
around the house are, from left to right,
Thomsine, Mrs. Headen, and Henrietta
H. (Courtesy of Mrs. Irene Inman.)

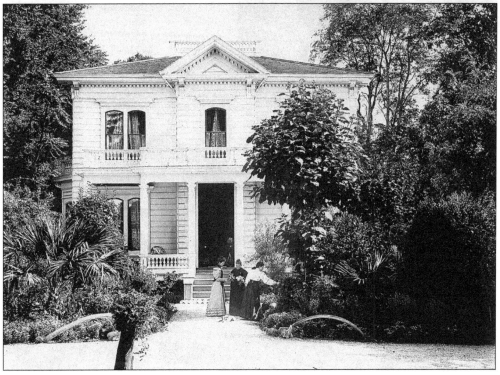

JESSE AND LOIS (HEADEN) INMAN. Lois Headen (1879–1972), daughter of George and Mary Eva Headen and granddaughter of Dr. B.F. Headen, married Jesse Jay Inman (1875–1963) on December 19, 1900, in Gilroy, California. The Inmans had two sons, Jesse Headen Inman (1901–1945) and Verne Inman (1905–1980). When Lois Inman died in 1972, Verne inherited her property, which he and his wife, Irene, used as a country home until 1980, when Verne died. (Courtesy of Mrs. Irene Inman.)

HEADEN-INMAN HOUSE. Thomasine Headen (1864–1934) and her husband, Louis Albertson (1868–1928), built this Craftsman-style home in 1913 to replace Dr. Headen's original house, said to have been damaged by fire. Lois (Headen) Inman inherited the property when Thomasine (Headen) Albertson died in 1934. In 1984 the house was donated to the City of Santa Clara and moved to its present site at 1509 Warburton Avenue, where it houses the Santa Clara Historic Museum. (Courtesy of Mrs. Irene Inman.)

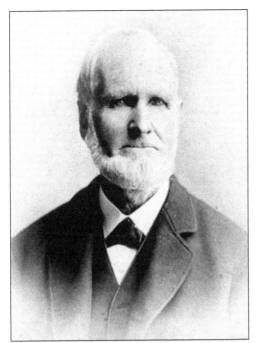
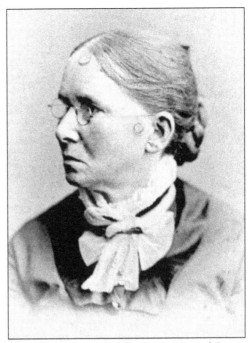

JAMES MONROE AND MARTHA (ROBERTS) KENYON. Martha Roberts (1828–1907) married James Monroe Kenyon (1817–1907) in Missouri in 1843. The Gold Rush brought them to California in 1849. After a brief stint in the gold fields, Kenyon purchased 242 acres on Homestead Road, two miles west of Santa Clara township, in 1850. The primary crops were hay and grain, although about 13 acres were later devoted to prunes. (Courtesy of Kenyon/Silva family.)

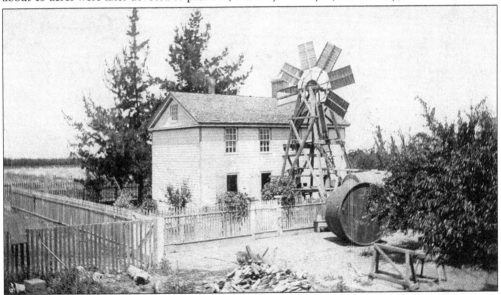

KENYON HOME AND WINDMILL. The Kenyons built a home on the family farm and lived there for 56 years, celebrating 64 years of marriage before they died within a few days of each other, in 1907. Five children were born and raised on the farm: John Fletcher (1855–1901), Benjamin "Frank" Franklin (1861–1948), James Monroe Jr. (1863–1927), and Harvey Thompson (1865–1887). (Courtesy of Kenyon/Silva family.)

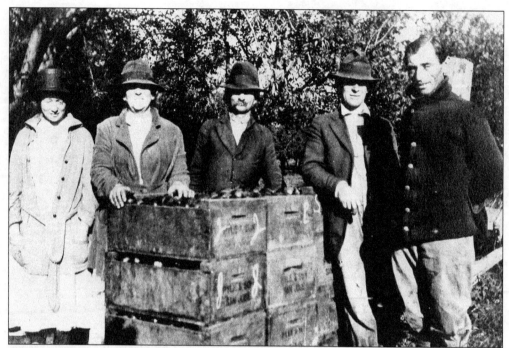

KENYON ORCHARD WORKERS. Workers shown in the Kenyon prune orchard in 1918 include Elizabeth Kenyon, daughter of Frank and Martha Kenyon, and Martha Kenyon, wife of Frank Kenyon, on the left. The man on the right is Alfred Kenyon, also a son of Frank and Martha Kenyon. (Courtesy of Kenyon/Silva family.)

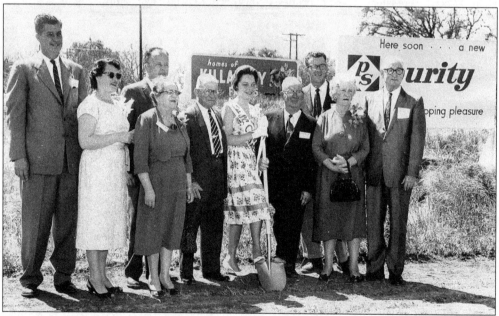

KILLARNEY FARMS GROUNDBREAKING. The majority of the Kenyon property was sold in 1960 for the Killarney housing development. Kenyon family members, from front left to right, are Doreen (Meston) Silva, Harriett (Kenyon) Meston, Alfred Kenyon, Miss Santa Clara, Frank Kenyon Jr., and Esther (Mrs. Alfred) Kenyon. (Courtesy of Kenyon/Silva family.)

CHARLES COPELAND MORSE. Charles Copeland Morse (1842–1900) came to California in 1862 and became a house painting contractor. He continued this business for 12 years, then became involved in seed growing. Morse spent 23 years in seed growing and earned the title of "Seed King of America." He was an influential citizen of Santa Clara as well as a founding member of the Santa Clara Advent Christian Church. (Courtesy of Santa Clara Historic Archives.)

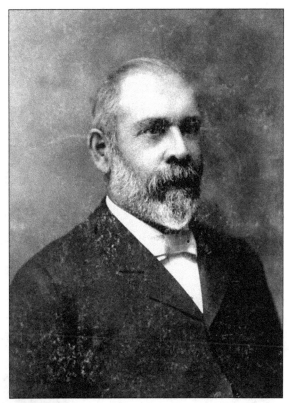

MARIA (LANGFORD) MORSE. Maria Langford (1845–1910) married Charles C. Morse. They had four children: Eva Augusta, born in 1869; Lester Langford, born in 1871; Stella May, born in 1873; and Winifred (Winnie), born in 1879. Maria was active in the Shakespeare Club and the Chatauqua movement and was a charter member of the Santa Clara Woman's Club when it organized in 1904. (Courtesy of Santa Clara Historic Archives.)

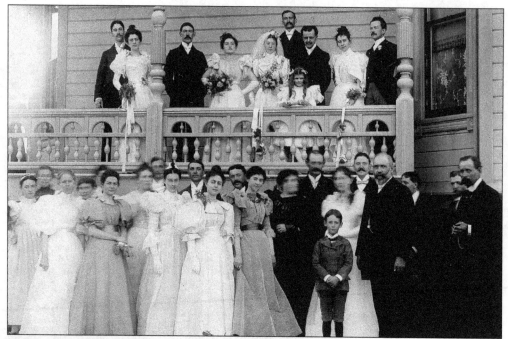

EVA MORSE WEDDING. Eva, the eldest daughter of Charles and Maria Morse, and her new husband, Fred Birge, are shown on the porch of the Morse Mansion on their wedding day. A bearded Charles Morse is shown on the far right in the row standing below the porch. (Courtesy of Warburton family.)

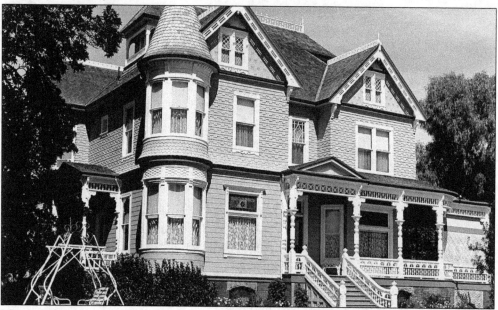

MORSE MANSION. In 1892, carpenter Zibeon O. Field built a magnificent Queen Anne Victorian for the Morse family at the corner of Fremont and Washington Streets. They had originally lived in a house on the grounds of the C.C. Morse Seed Company. After the death of her parents, daughter Stella and her husband, George Hamilton, lived in the house from 1915 to 1930. (Courtesy of Santa Clara Historic Archives.)

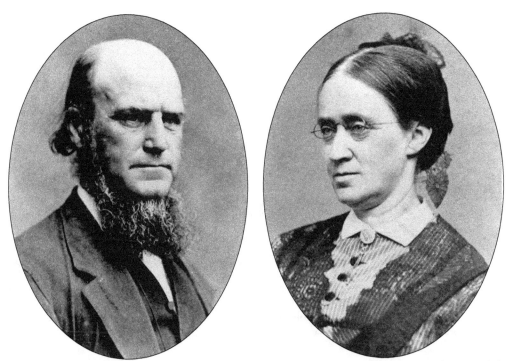

DR. ARTHUR WELLSLEY AND MARY (JUDSON) SAXE. Dr. Arthur Wellsley Saxe (1820–1891), born in New York, crossed the plains to California in 1850. After practicing for a year as a doctor in the gold mining area, he moved to Santa Clara. Mary Judson, born in Connecticut, married Saxe, her cousin, in 1844. Mary and her children, Frederick and Libby, came to California by sea and across the Isthmus of Panama in 1852. (Courtesy of Mary Pascoe to Bea Lichtenstein Collection.)

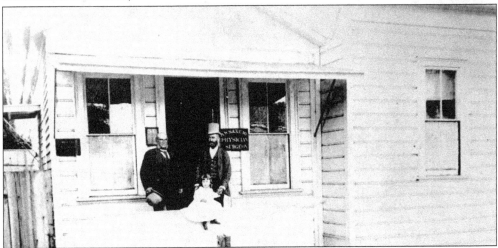

DR. SAXE'S OFFICE. Dr. Saxe built an office on Main Street adjoining his home. The office was moved around the corner to its present site on Benton Street, near Dr. Paul's house at Benton and Washington Streets. Pictured, from left to right, are Dr. A.W. Saxe, his granddaughter Helen, and his son, Dr. Francis Keith Saxe. This landmark structure now serves as a home, with the porch removed and the door replaced with a window. (Courtesy of Mary Pascoe to Bea Lichtenstein Collection.)

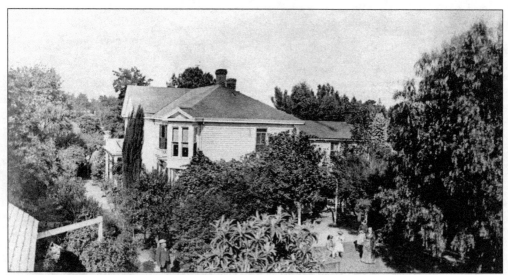

DR. SAXE'S HOUSE. Dr. Saxe built a Greek Revival–style home on the corner of Benton and Main Streets after his arrival in 1851. This landmark structure, with some alterations, remains in its original location. An avid horticulturalist, Saxe maintained extensive floral and botanical gardens on his property. (Courtesy of Mary Pascoe to Bea Lichtenstein Collection.)

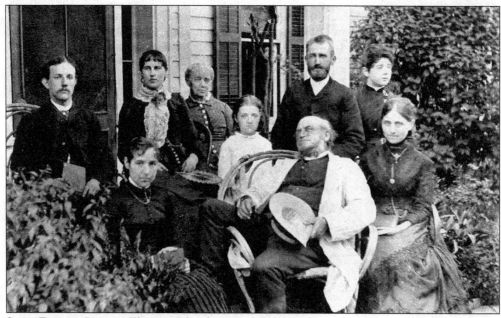

SAXE FAMILY GROUP. The Saxe family visits with friends on the porch of Dr. Saxe's home. Pictured are Dr. A.W. Saxe (seated in front); (back row) Mary (Judson) Sax (the gray-haired lady in center); granddaughter Mabel Saxe, who was raised by her grandparents after her mother, Carrie, died; son Dr. Francis Keith Saxe, and his wife, Mary Jane (Cook) Saxe. The visiting friends are not identified. (Courtesy of Mary Pascoe to Bea Lichtenstein Collection.)

Four

BUSINESS AND INDUSTRY

LEVI A. GOULD ORCHARDS. Levi Ames Gould, pioneer orchardist and artisan well driller, cultivated orchards located on the northwestern limits of Santa Clara, at the corner of Old San Francisco Road and Scotts Lane (now El Camino and Scott Boulevard). Gould shipped California's first carload of fresh fruit on October 12, 1869, shortly after completion of the transcontinental railroad. (Alice Hare photo; courtesy of Santa Clara City Library, Clyde Arbuckle Collection.)

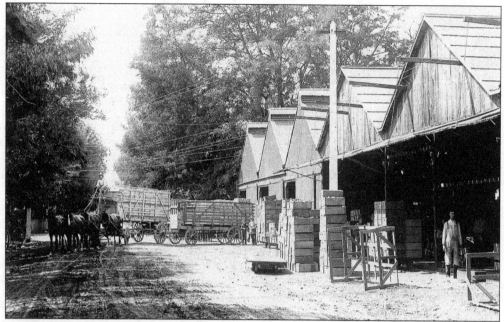

A. Block Packing Company Warehouse. Abram Block, one of the pioneers in placing California's deciduous fruits on the world's markets, bought the land and orchards of Levi Ames Gould and established A. Block Fruit Packing Company in 1873. The Block packing warehouses were located on the corner of what is now El Camino and Scott Boulevard. (Alice Hare photo; courtesy of Santa Clara City Library, Clyde Arbuckle Collection.)

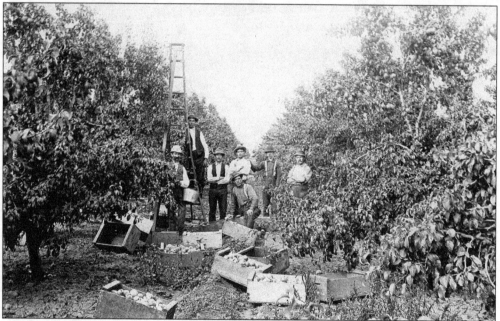

Men Picking Pears. Block realized early the potential of deciduous fruit and hastened to take advantage of it. By 1907 he had nearly 200 acres bearing a variety of plums, pears, and cherries. The men in this photograph are picking pears in Block's orchards. (Alice Hare photo; courtesy of Santa Clara City Library, Clyde Arbuckle Collection.)

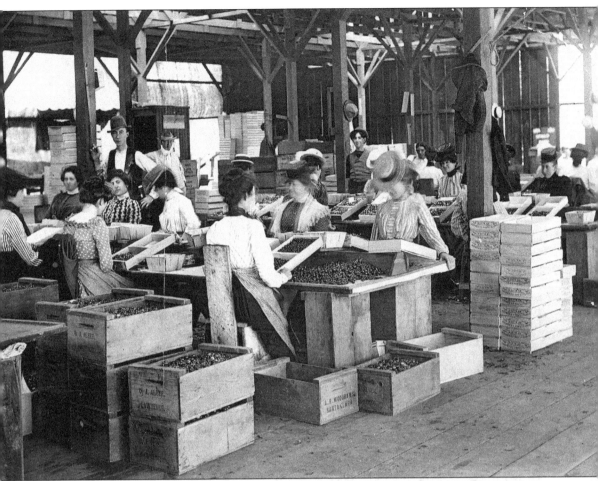

LADIES PACKING CHERRIES. The fruit packing season at the Block establishment ran from May, when the cherries began to appear in abundance, until the last of the winter pears were packed in late October. The well-dressed ladies shown in this Alice Hare photograph are busily packing cherries. Many tons of Santa Clara cherries were packed here annually for the eastern market. The Block Packing Company packed only the choicest fruits, their brand having a reputation second to none. (Alice Hare photo; courtesy of Santa Clara City Library. Clyde Arbuckle Collection.)

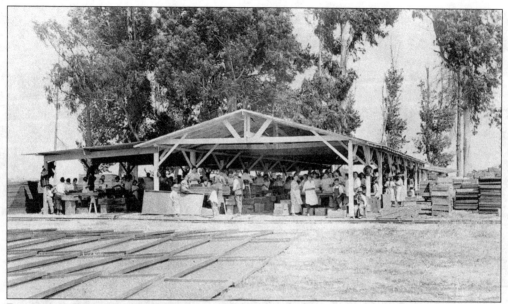

ROSENBERG BROS. CUTTING SHED. Rosenberg Bros. took over the Cured Fruit Association's lease from the City of Santa Clara and occupied its plant on Railroad Avenue, near the Santa Clara train depot. Men, women, and children, especially women and girls, cut and pitted the fruit and then placed it on wooden trays, which were set out on the ground to dry. Charles D. South was the foreman when this photo was taken about 1924–1925. (Courtesy of Mary Certa and Charles D. South family.)

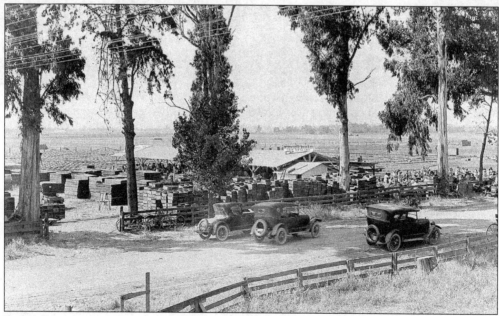

ROSENBERG BROS. DRYING YARD. Rosenberg Bros. fruit drying yard on Brokaw Road, near the Santa Clara train depot, is shown *c.* 1925, with trays of cut fruit (probably apricots) set on the ground to dry. The Santa Clara plant packed every variety of fruit as well as nuts. By 1919 it employed 400 people at the height of the season. (Courtesy of Mary Certa and Charles D. South family.)

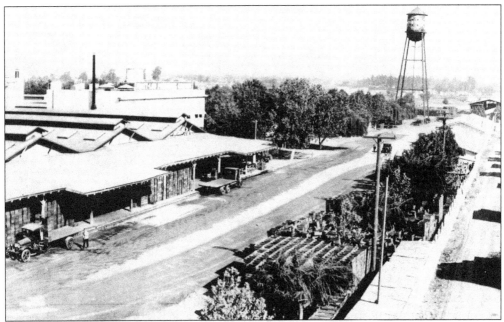

PRATT-LOW PRESERVING COMPANY PLANT. The Pratt-Low Preserving Company opened in 1905 on three acres just south of the Southern Pacific Railroad depot. By 1922 the company had expanded to accommodate a thriving business that employed 400 to 1,000 people during fruit harvesting season, which lasted from June to mid-November. (Courtesy of Ron Rose Collection.)

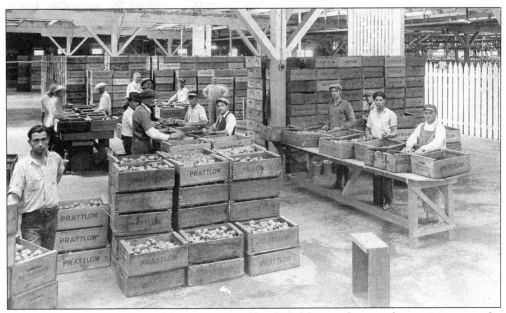

PRATT-LOW SORTING AREA. The cannery itself included four work areas: the receiving area, the preparation room, the cooking room, and the warehouse. After the fruit arrived at the receiving area in the plant, the boxes were carried to the scales, just inside the door, for weighing. The weighed fruit was sorted according to size and then the boxes were stacked and carried on hand trucks to the preparation room. (Courtesy of Cunha family.)

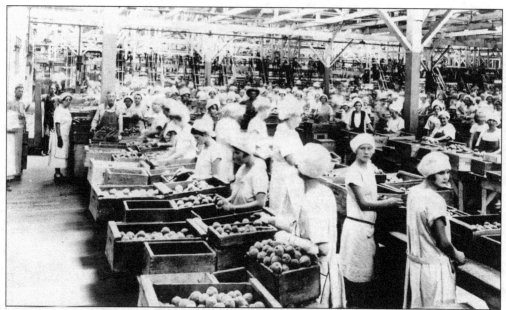

PRATT-LOW CUTTING ROOM. In the cutting room, a 40-pound box of fruit and several smaller boxes were placed in front of the ladies at the cutting tables. As the operator cut, pitted, or cored, she sorted the fruit again according to size and firmness. The grade of the fruit was marked with chalk on each completed box. Men then carried the graded fruit to the canning tables. (Courtesy of Ron Rose Collection.)

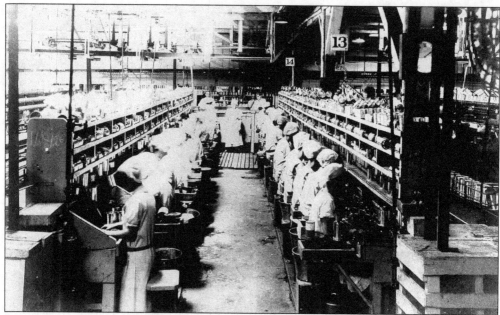

PRATT-LOW CANNING TABLES. At the canning tables, cut and graded fruit was washed and put in cans. The cans then went to the "syrupers," after which a can lid was placed over the opening and soldered, leaving a venting hole. In the cooking room, the cans went into vats of boiling water. After removal from the cookers, the vent hole was soldered and the cans were returned for a second cooking. (Courtesy of Ron Rose Collection.)

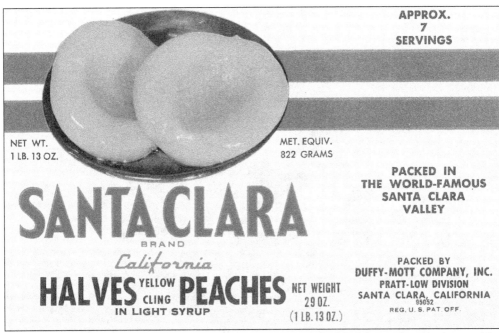

PRATT-LOW LABEL. The Pratt-Low Preserving Company packed California fruits and vegetables for 55 years, until 1960, when the Duffy-Mott Company assumed the lease of the 407,000-square-foot plant. The colorful labels on the finished cans not only identified the contents, but were "works of art" reflecting the fruit industry that thrived in Santa Clara and Santa Clara Valley. (Courtesy of Bea Lichtenstein Collection.)

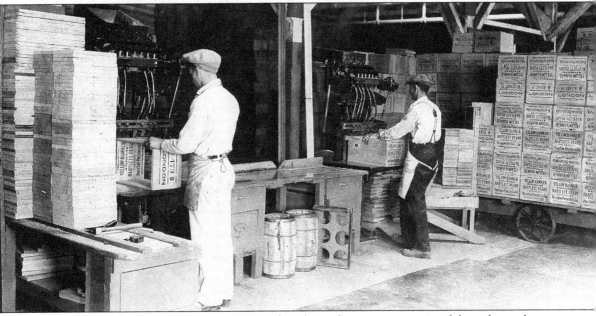

PRATT-LOW BOX MAKING. After the second cooking, the cans were removed from the cooker and left until morning, when they were tested for air tightness. The cans were stacked and sent to the warehouse where they were labeled and then stored in boxes made by the men at Pratt-Low before being shipped in railroad cars to the markets of the world. (Courtesy of Cunha family.)

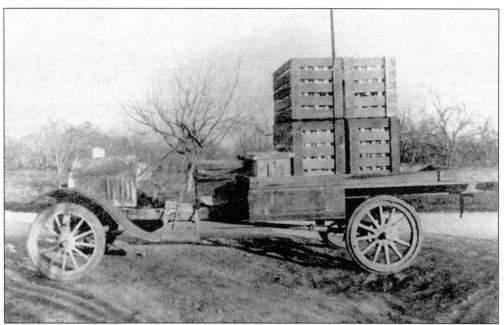

ORCHARD TRUCK. Boxes of fruit picked in the orchards were hauled to the processing plant, first by horse and wagon and then later by trucks, such as the one shown here. (Courtesy of Santa Clara Historic Archives.)

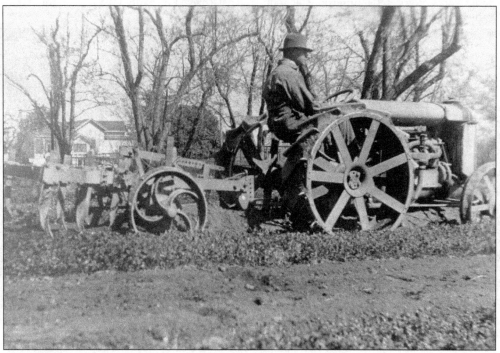

EARLY TRACTOR DISKING ORCHARD. Early disking of orchards was done by horse and plow. The task became easier and faster with the advent of mechanized tractors. (Courtesy of Santa Clara Historic Archives.)

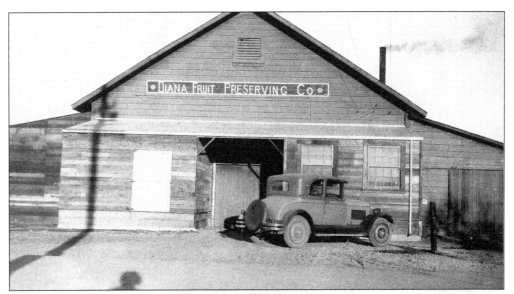

DIANA FRUIT COMPANY. In 1921 Yugoslavian emigrant Alexander Diana established Diana Fruit Preserving Company. Diana brought with him a formula for "non-bleeding cherries" that would not stain the fruits used in fruit cocktail. When Diana died in 1941, his son-in-law Eugene A. Acronico Sr. took over the business. E.A. Acronico Jr. now serves as president of Diana Fruit, which today is the lone survivor of the fruit industry that once thrived in Santa Clara. (Courtesy of Eugene Acronico.)

RUMBOLZ ORCHARD AND NURSERY. The Rumbolz family property, as it looked c. 1950, consisted of a barn, prune dehydrator, tank house, home, greenhouses, and 12 acres of prune trees. The prune dehydrator on the left was used to dry prunes for Homestead Road orchardists. When the property, which was located on Homestead Road at San Tomas Expressway, was sold to a developer, the tank house was relocated to the Harris-Lass farm museum site. (Courtesy of Hart Rumbolz.)

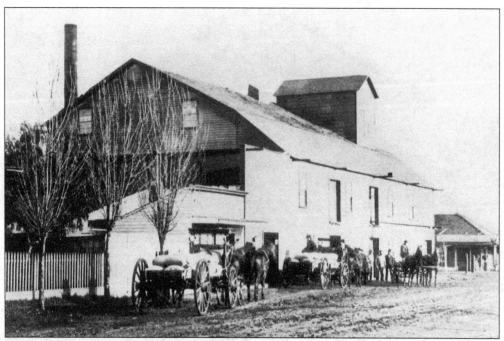

SANTA CLARA FLOUR MILL. When Nathaniel Cook arrived in Santa Clara in 1857, he became one of the first engineers employed by the old Santa Clara Flour Mill, of which he later became part owner. (Courtesy of Mary Pascoe to Bea Lichtenstein Collection.)

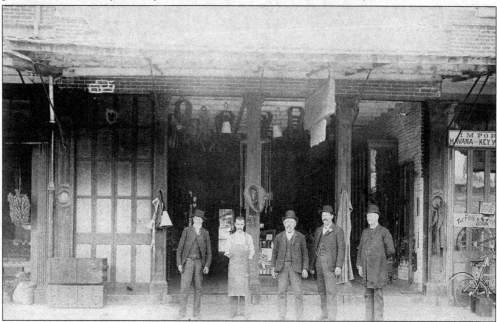

FRANCK HARNESS & SADDLERY. After settling in Santa Clara, Frederick Christian Franck became an employee in Henry Messing's harness and saddlery business. Messing retired in 1859 and Franck then became sole owner of the business, selling it in 1875. Pictured in front of the business about 1894–1895, from left to right, are Mr. Sykes, F. Larder, F.C. Franck, Mr. Abrahams, and Mr. McQouid. (Courtesy of Bea Lichtenstein Collection.)

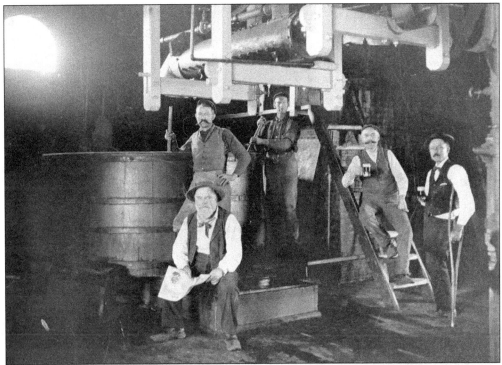

SANTA CLARA BREWERY. Born in Germany in 1838, George Lauck came to America at age 16 and settled in Galena, Illinois, where he learned the art of brewing. Lauck settled in Santa Clara in 1878 and purchased the Santa Clara Brewery, located on the southwest corner of Benton and Alviso Streets. Lauck is pictured sitting in front of the brewing kettles. Behind him, from left to right, are unidentified, Ed Park, Fred Fischer, and Mr. Gephart. (Courtesy of Santa Clara Historic Archives.)

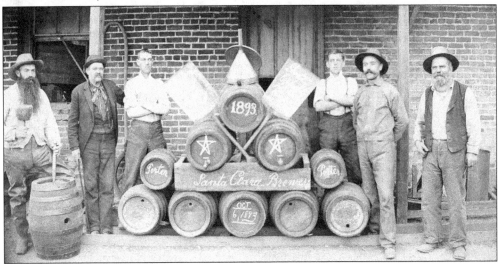

SANTA CLARA BREWERY. Santa Clara Brewery workers, from left to right, are Charles Koenig, unidentified, Frank Lauck, Gus Ritter, Fred Fischer, and George Lauck pose in front of the brewery, October 6, 1893. Santa Clara Fire Station No. 1 is now located on the old brewery site. (Courtesy of Santa Clara Historic Archives.)

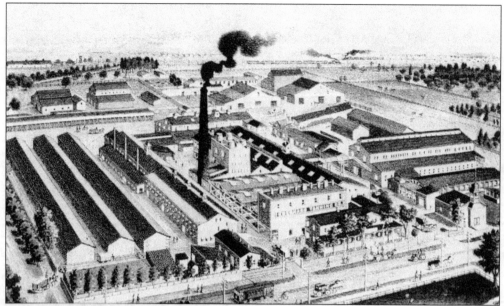

EBERHARD TANNERY. Jacob Eberhard (1837–1915) came to Santa Clara in 1865 and bought a part interest in Santa Clara Tannery. By 1915 Eberhard Tanning Company occupied 11 acres and was one of the largest tanneries in the world. Shown in the center is the 80-foot smokestack, which fell in the 1906 earthquake, the tannery boarding house (in center foreground), and, on the far right, the Tanner Hose Company building. (Courtesy of Santa Clara Historic Archives.)

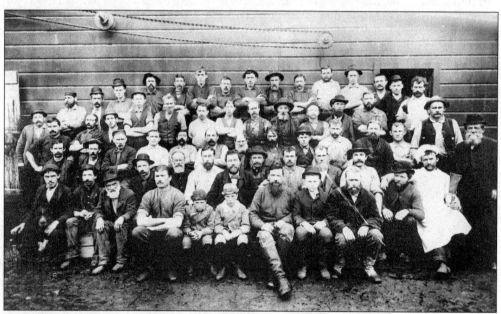

EBERHARD TANNERY EMPLOYEES. Eberhard Tannery provided employment for newly arrived immigrants from Germany and also provided employment, at times, for as many as one in five Santa Clarans. Eberhard Tannery grew to be the largest of its kind in California, eventually employing 70 men with an annual payroll of $50,000. Due to the reduced need for leather, the business closed in 1953, after 170 years of operation. (Courtesy of Santa Clara Historic Archives.)

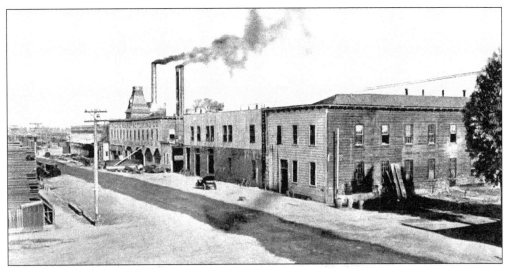

PACIFIC MANUFACTURING COMPANY. James Pierce bought Enterprise Mill and Lumber Company in Santa Clara in 1874. Pierce changed the name to Pacific Manufacturing Company when the business incorporated in 1879. (Courtesy of Santa Clara Historic Archives.)

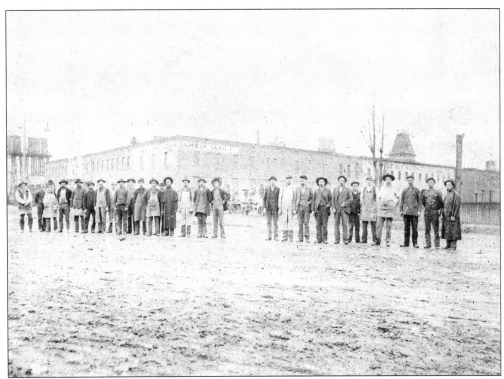

PACIFIC MANUFACTURING COMPANY WORKERS. Pacific Manufacturing Company provided employment for many workers from its beginning in 1879 until its ultimate closure in 1960. The company employees had a "tug of war" team as well as a softball team. (Courtesy of Santa Clara Historic Archives.)

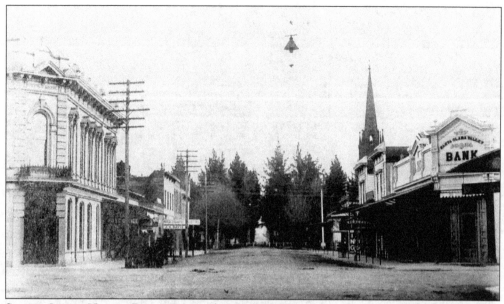

SANTA CLARA VALLEY BANK. Santa Clara Valley Bank, on the corner of Franklin and Main Streets, incorporated on May 31, 1893. The officers were Lester A. Morse, president; Abram Block, vice president; and E.F. Jordan, cashier. (Courtesy of Santa Clara Historic Archives.)

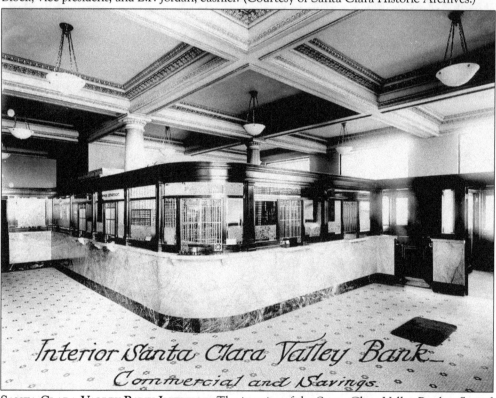

SANTA CLARA VALLEY BANK INTERIOR. The interior of the Santa Clara Valley Bank reflected the elegant nature of the period with its marble counters and floors. (Courtesy of Santa Clara Historic Archives.)

GEORGE MILOVICH VEGETABLE WAGON. George Milovich delivered fresh vegetables to the people of Santa Clara by horse-drawn wagon. (Courtesy of Santa Clara Historic Archives.)

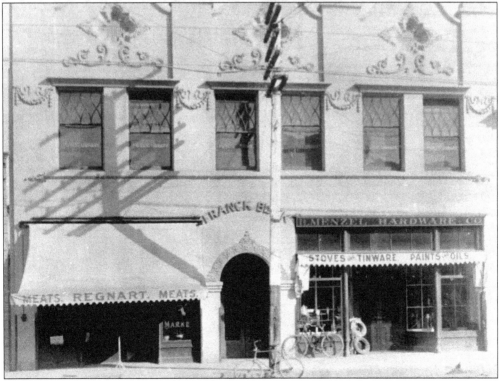

FRANCK BUILDING. Frederick Christian Franck I erected the Franck Building on Franklin Street, which housed Regnart Meats and Menzel Hardware on the street level. The second floor housed the Santa Clara Public Library until 1913 when the library moved into the new city hall on the corner of Franklin and Washington Streets. (Courtesy of Santa Clara Historic Archives.)

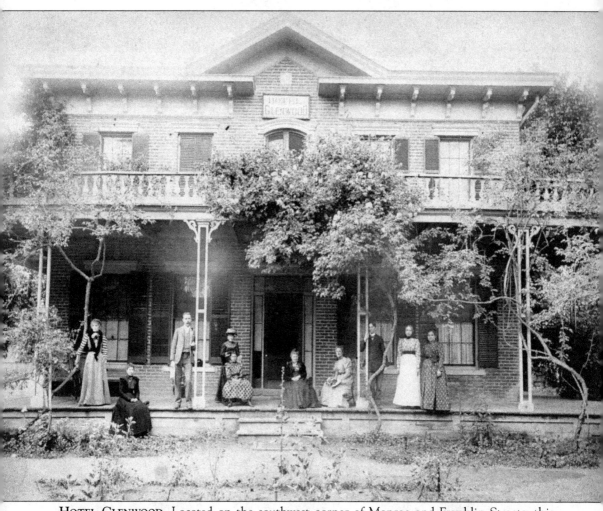

HOTEL GLENWOOD. Located on the southwest corner of Monroe and Franklin Streets, this structure was originally built in the 1850s as the home of Robert Seydel. In 1882 it became the Hotel Glenwood. Many unmarried school teachers boarded here if they had no family to live with in the city. The Glenwood Hotel site later served as the Safeway store and, still later, as the site for Coast to Coast Hardware. (Courtesy of Irving Cabral Collection/Santa Clara Historic Archives.)

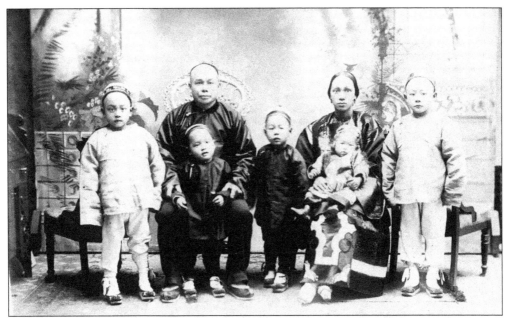

SING KEE AND FAMILY. Sing Kee first worked as a cook for the family of Dr. A.W. Saxe after coming from China. Later, he operated a laundry on Liberty Street, now Homestead Road. Sing Kee gained a reputation as a weather prognosticator using a toad to make his predications. Fr. Ricard, S.J., of Santa Clara College predicted the weather by using a forecasting method based on sunspots. (Courtesy of Mary Pascoe to Bea Lichtenstein Collection.)

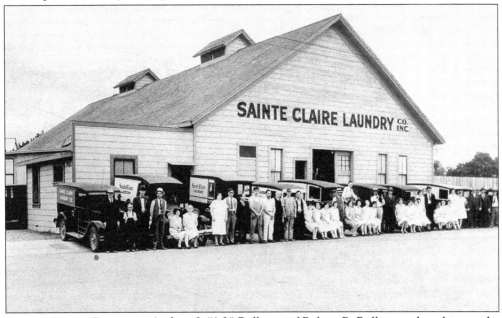

SAINTE CLAIRE LAUNDRY. Andrew J. "A.J." Roll, son of Robert B. Roll, started working at the Enterprise Laundry at the age of 15. The Enterprise Laundry became Sainte Claire Laundry Co. Inc. in 1927. In 1935 A.J. Roll assumed sole ownership of the business and continued to operate it until it finally closed in 1970. (Courtesy of Santa Clara City Library, Leonard McKay's Clyde Arbuckle Collection.)

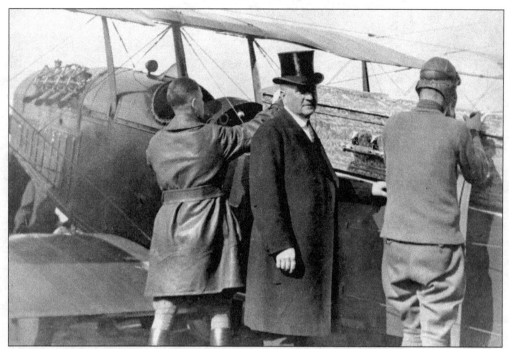

BIPLANE WITH CASKET. This unusual photograph shows the pilot of the De Haviland biplane either taking off or tying on a casket. The man in the top hat is presumed to be the funeral parlor director. The location of this picture is unknown, but perhaps it was taken at the Oak Hill Memorial Cemetery in San Jose. (Courtesy of Santa Clara Historic Archives.)

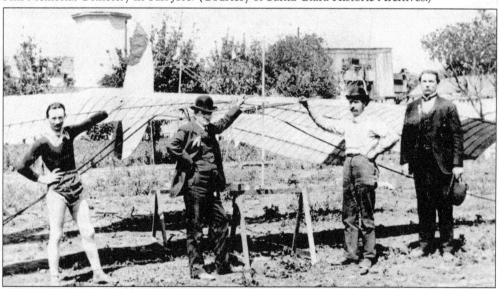

JOHN MONTGOMERY AND GLIDER. Pioneer aviator John J. Montgomery came to Santa Clara College in 1896 and worked on his "aeroplanes" and theories of flight. Montgomery was the first American to fly a heavier-than-air machine. In this 1905 photograph, Montgomery (center) stands by his glider, "The Santa Clara," with stuntman Daniel Maloney (left) who guided the flight of the glider after it was cut loose from a hot air balloon. (Courtesy of Santa Clara Historic Archives.)

Five

EDUCATION

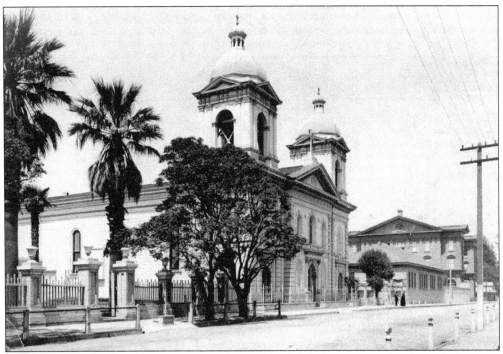

SANTA CLARA COLLEGE. In March 1851, Jesuit priests Michael Accolti and John Nobili arrived to establish Santa Clara College at the old Mission Santa Clara site. Transforming the rundown "ugly duckling" into a creditable school of higher learning was a formidable task that took place through the 1860s, 1870s, and 1880s. By 1912 the physical facilities and curriculum had improved to the point where Santa Clara College achieved the title of university. (Courtesy of Santa Clara University Archives.)

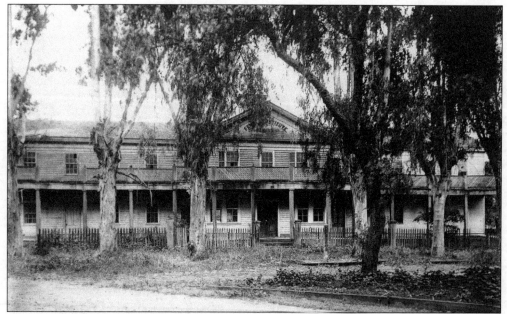

FEMALE COLLEGIATE INSTITUTE. The Methodist Church founded the College of the Pacific in Santa Clara in 1851. The Female Department, called the Female Collegiate Institute, operated separately from the Male Department and had its own building with separate classes taught by its own faculty. The institute's 70-room building was located on Main Street, just west of the town plaza. (Courtesy of Santa Clara University Archives.)

REMODELED FEMALE INSTITUTE. The Female Collegiate Institute occupied their building until 1871, when College of the Pacific left Santa Clara and moved to a new location in San Jose. James M. Kenyon, an early Santa Clara pioneer and Methodist Church member, bought the old building and, in 1907, demolished one section of the relic. The northern section was remodeled and used as an apartment building. (Courtesy of Kenyon/Silva family.)

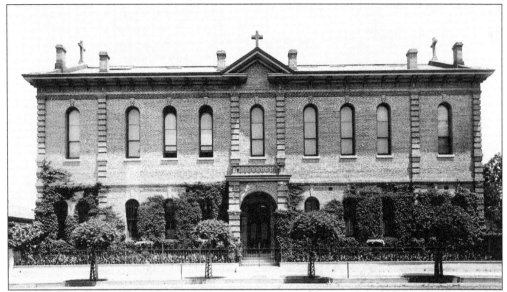

NOTRE DAME ACADEMY. In 1864 the Sisters of Notre Dame opened a private academy for girls and young ladies in Santa Clara, which first operated under the name of St. Mary's and then the Notre Dame Academy. The grand home of James Alexander Forbes, one of the earliest pioneers in Santa Clara, was utilized for the school until another structure was erected. (Courtesy of Mary Certa and Charles D. South family.)

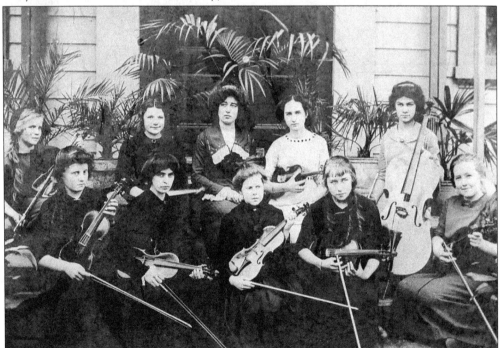

NOTRE DAME ACADEMY ORCHESTRA. Notre Dame Academy provided a well-rounded curriculum for its students. The cultural arts were emphasized as well. The young ladies of Notre Dame Academy received musical instruction and the school orchestra is shown here. (Courtesy of Santa Clara City Library, Leonard McKay's Clyde Arbuckle Collection.)

FIRST PUBLIC SCHOOL TEACHER. The first permanent school in Santa Clara, the Little Brick School, opened in 1850. Mrs. Mary E. Stuart was the first teacher at the Little Brick School, which taught the first four grades, or the so-called Primary Department. (Courtesy of Santa Clara Woman's Club Archives.)

SANTA CLARA GRAMMAR SCHOOL. Santa Clara Grammar School, built in 1867, served both elementary and high school students until a separate Santa Clara High School opened in 1905. The school was on Monroe Street, between Fremont and Harrison Streets, where the Senior Center is now. (Courtesy of Santa Clara City Library, Clyde Arbuckle Collection.)

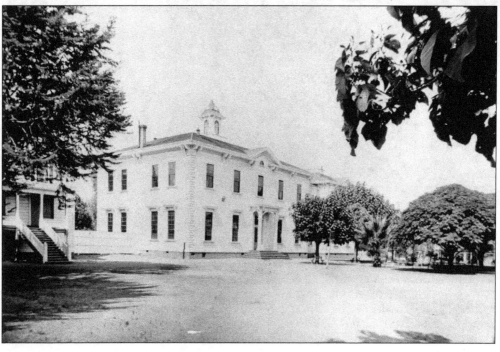

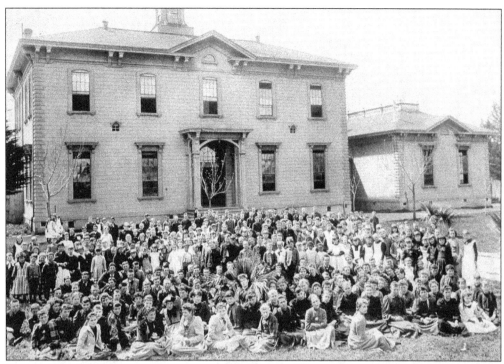

SANTA CLARA GRAMMAR SCHOOL AND STUDENTS. The students of Santa Clara Grammar School gathered for a group picture in 1895. In 1870 the enrollment totaled 260, and by 1900 had grown to 940, reflecting the growth of the City of Santa Clara. (Courtesy of Santa Clara City Library, Clyde Arbuckle Collection.)

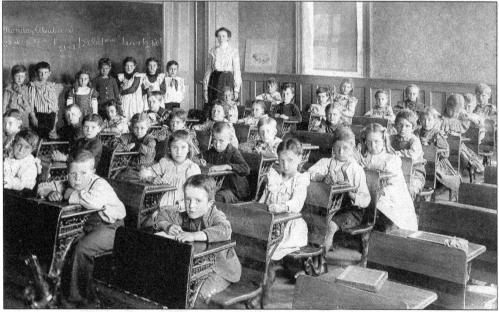

1901 GRAMMAR SCHOOL CLASSROOM. A primary class at Santa Clara Grammar School works on multiplication on Monday, April 29, 1901. For the observant, the date is written on the blackboard. (Courtesy of Santa Clara Unified School District Archives.)

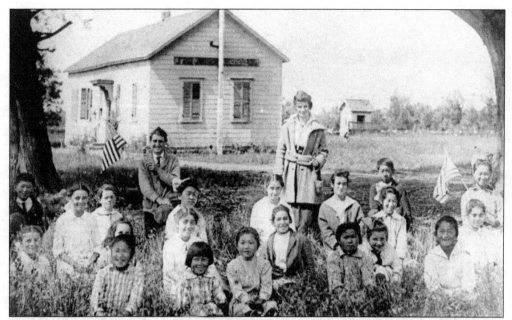

JEFFERSON SCHOOL AND ELLA SHARP. The original Jefferson School, a small wooden building of one room, organized about 1861 and was located on Kifer Road on the northeast bank of San Tomas Creek, now San Tomas Expressway. Mrs. Ella (Brown) Sharp taught many years at Jefferson School. She was a member of the Brown family who grew Bartlett pears in the Jefferson District, where Great America is now located. (Courtesy of Santa Clara Unified School District Archives.)

JEFFERSON SCHOOL 1897 GRADUATES. It's a flag-waving day in 1897 as 10 students celebrate their graduation from Jefferson School. (Courtesy of Santa Clara Unified School District Archives.)

MILLIKIN WHITE-WASHED SCHOOL. The original Millikin School, established in 1855 and named for John Millikin, who owned a farm located on Lawrence Station Road, was a little, one-room, redwood cabin with white-washed walls. (Courtesy of Santa Clara Unified School District Archives.)

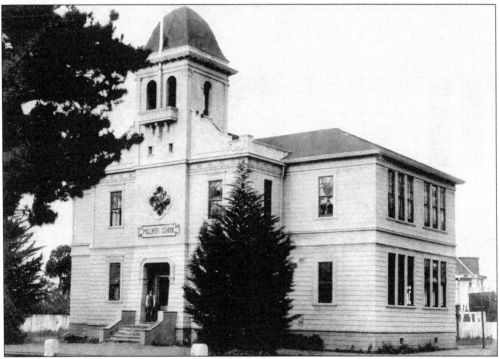

SECOND MILLIKIN SCHOOL. This second, larger, two-story building replaced the original, white-washed, rural Millikin School. Millikin School was the largest of the four rural schools that became part of the Jefferson Union School District and, eventually, Santa Clara Unified School District. After the school closed in 1927, the building became home to the Yugoslavian Naperdak Hall. (Courtesy of Santa Clara Unified School District Archives.)

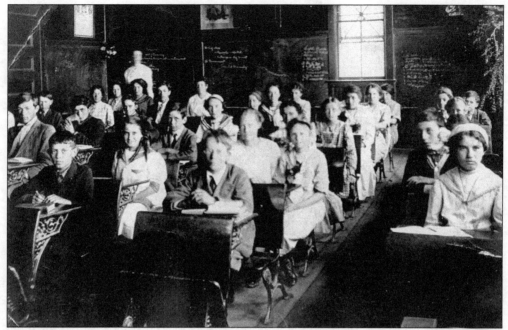

FRANK KENYON JR. CLASS. The class of Miss Lea Reed at Millikin School shows Arthur Butcher, the large boy in the far left front desk, and Frank Kenyon Jr., the grandson of Santa Clara pioneer James Monroe Kenyon, in the middle front desk. The varying sizes of the students indicate that this is a one-room rural school with all eight grades. (Courtesy of Kenyon/Silva family.)

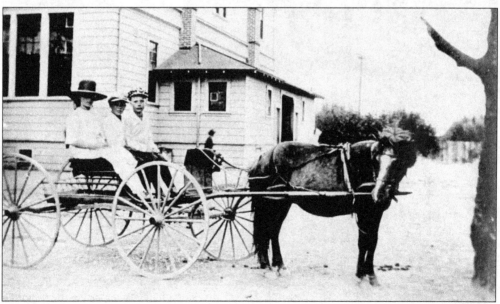

MILLIKIN SCHOOLCHILDREN IN BUGGY. Most of the students who attended the rural schools in the Jefferson, Braly, and Millikin districts probably walked to school. Some children had the "luxury" of other means of transportation, such as the horse and buggy shown here at the rear of the second Millikin School. (Courtesy of Santa Clara Unified School District Archives.)

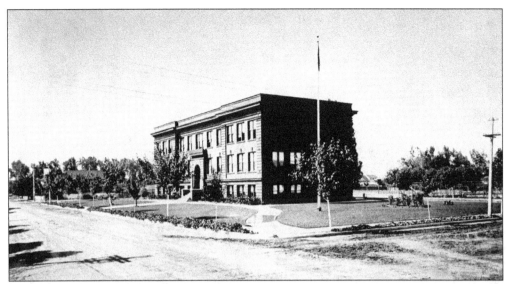

1905 SANTA CLARA HIGH SCHOOL. Due to crowded conditions at Santa Clara Grammar School, a separate high school opened in 1905, built on land acquired by the school board many years prior. The family of Clyde Arbuckle, deceased San Jose historian, lived in a rented home on the school site. The new Santa Clara High opened with an enrollment of 175 students and a staff of 10. (Courtesy of Santa Clara Historic Archives.)

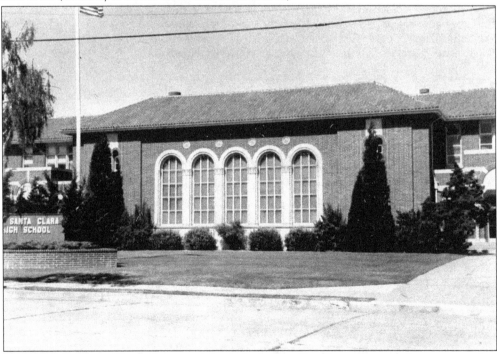

1922 SANTA CLARA HIGH SCHOOL. A larger high school building was needed to accommodate the growing student body and, in 1922, a second Santa Clara High was erected on a site adjoining the 1905 structure. The former high school building then served the sixth, seventh and eighth grades, thus becoming the first intermediate school in Santa Clara. (Courtesy of Santa Clara Unified School District Archives.)

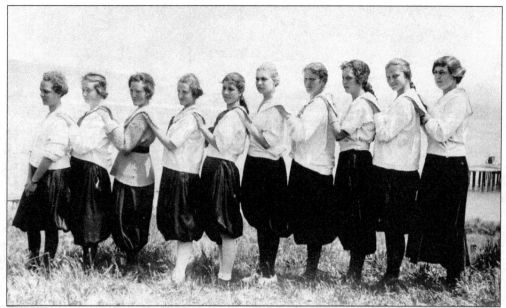

"BLOOMER GIRLS" SOFTBALL TEAM. The 1922 Santa Clara High School softball team included, from left to right, Bobby Spegleman, second base; Elizabeth "Cookie" Kenyon, shortstop; Melvina Walcolz, catcher; ? Carroll, shortstop and second base; Sara Jenkins, third base; Johanna Lass, left field; Margaret Jenkins, pitcher; Arline McClellan, centerfield; Emma Roberts, right field; and Miss McNab, coach. Margaret Jenkins was an outstanding athlete who was Santa Clara County's first woman athlete to compete in the 1928 Olympics in Amsterdam. (Courtesy of Margaret Jenkins to the Bea Lichtenstein Collection.)

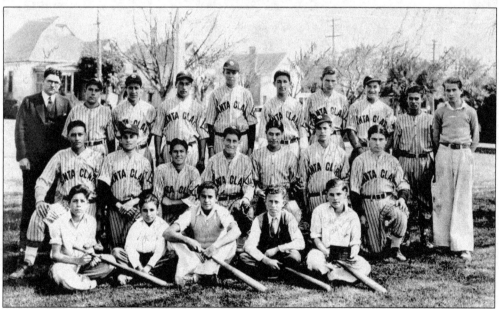

SANTA CLARA HIGH BASEBALL TEAM. The Santa Clara High Baseball Team, shown here with their coach, Mr. Cowden, wearing a suit at far left, won a championship in 1932. (Courtesy of Santa Clara Historic Archives.)

FREMONT SCHOOL. Fremont School, built on the old Santa Clara Grammar School site, opened on September 15, 1913. Miss Isabel, school principal, reported the enrollment at 542 students on October 29, 1913. (Courtesy of Santa Clara Unified School District Archives.)

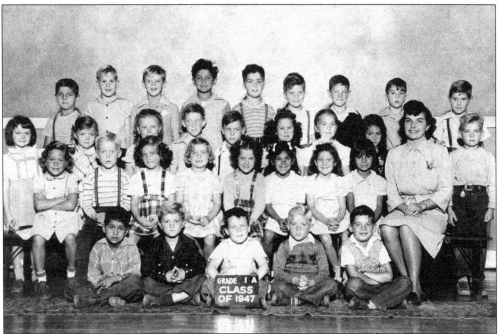

MARY GOMEZ AND CLASS. Mary (Sanchez) Gomez attended Fremont School and began her teaching career there in 1946. She continued teaching at Freemont for 20 years until, as she says, "the school was torn down around" her in 1966. Gomez is shown here with her first class in 1947. (Courtesy of Mary Gomez.)

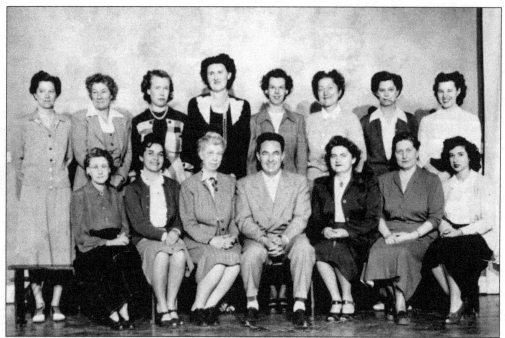

FREMONT SCHOOL TEACHERS. The teaching staff at Fremont School in 1948, from left to right, included the following: (front row) Emily Scott, Mary Gomez, Edith Lamb, Raymond Ruf, Frances Chaney, Catherine Mead, and Lola Johnson; (back row) Ruth Davis, Margaret Jenkins, Martha Wegman, Loretta Shields, Gloria Rogers, Margaret Wibel, Naomi Koehle, and Virginia Brasfield. (Courtesy of Mary Gomez.)

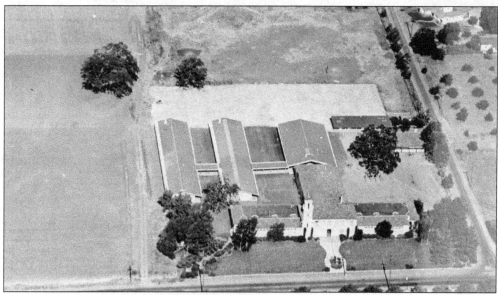

AERIAL VIEW OF JEFFERSON UNION SCHOOL. The rural schools of Braly, Jefferson, and Millikin formed the Jefferson Union School District. The newly built Jefferson School, shown in this aerial view, was located on the corner of Lawrence Station Road and what is now Monroe Street. The school opened in 1927. (Courtesy of Santa Clara Unified School District Archives.)

JEFFERSON UNION SCHOOL. The new Jefferson School was a world apart from the old rural schools it replaced, with classrooms for each grade, a wood shop for the boys, a domestic science room for the girls, a cafeteria, and an administration office. (Courtesy of Santa Clara Unified School District Archives.)

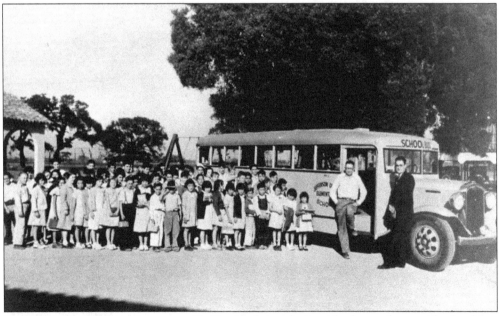

LAWRENCE C. CURTIS. Lawrence C. Curtis, shown here with the students and school bus driver, taught physical education and manual training and, on occasion, drove the bus. Curtis became principal and superintendent in 1932 and served until 1966, when Santa Clara Unified School District formed and he became its first superintendent. (Courtesy of Santa Clara Unified School District Archives.)

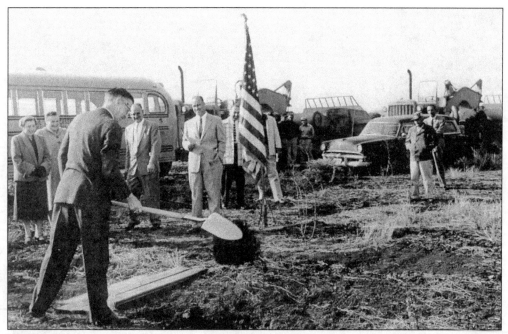

BUCHSER HIGH SCHOOL GROUNDBREAKING. Buchser High School, named for Emil R. Buchser, opened in September 1959 at 3000 Benton Street. Shown at the groundbreaking in November 1957, from left to right, are school board member Marian A. Peterson, Counselor Jana Shaw, school board president William A. Wilson (with the shovel), Superintendent Emil R. Buchser, Deputy Superintendent Wendell Huxtable, and contractor Bill Nicholson (left of flag in plaid jacket). (Courtesy of Don Callejon.)

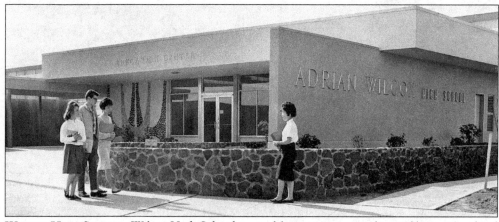

WILCOX HIGH SCHOOL. Wilcox High School, named for prominent rancher and longtime school board trustee Adrian Wilcox, opened in 1961. (Courtesy of Santa Clara Historic Archives.)

Six

SOCIAL LIFE
AND COMMUNITY

INTERNATIONAL ORDER OF ODD FELLOWS HALL. Santa Clara Lodge No. 52 of IOOF organized on January 18, 1856. A large lodge room, anterooms, and reception rooms were built over a first-story commercial area at the southwest corner of Franklin and Washington Streets on July 1, 1868. Other beneficial and fraternal associations, such as the Masons and Eastern Star, rented the Odd Fellows facilities for their functions and meetings. (Courtesy of Santa Clara Woman's Club Archives.)

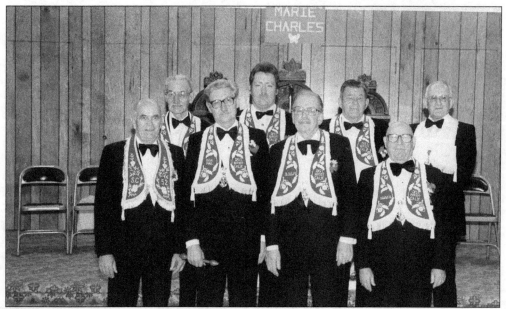

ODD FELLOWS OFFICERS. IOOF Santa Clara Lodge No. 52 installing officers for 1986, from left to right, included the following: (front row) Clarence Carothers, Ed Carney, John Roberts, and Leland Kirk; (back row) Ted Carney, Tom Bradley Sr., Charles Henderson, and Dick Miller. The Odd Fellows remained in Santa Clara until their building was demolished as part of the 1960s urban renewal project, which razed eight square blocks of Santa Clara's downtown. (Courtesy of Leland Kirk.)

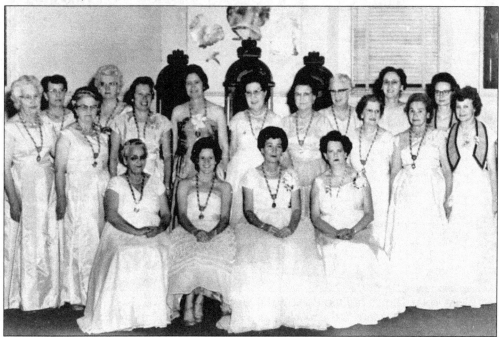

REBEKAHS. The female counterpart of the Odd Fellows was called the Rebekahs. Clara Rebekah Lodge No. 34 was instituted on June 9, 1877. The elegantly clad Rebekahs gathered for a formal photograph after an installation. (Courtesy of Leland Kirk.)

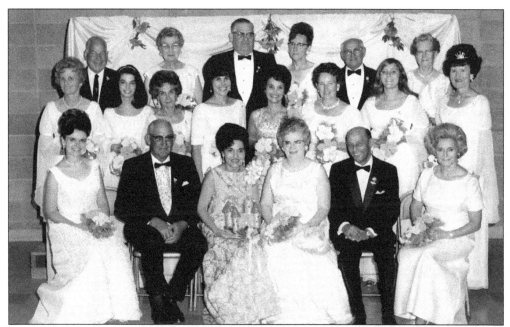

ORDER OF EASTERN STAR. Santa Clara Chapter 195, Order of Eastern Star, received its charter on October 16, 1901. Meetings were held at the IOOF Hall until the Masons built their new Masonic Temple on Scott Boulevard. The Eastern Star officers installed in 1971, from left to right in the front row, included Kathleen McDonald, Worthy Patron Lee Cook, Worthy Matron Marie Heiner, Alicia Slocum, John Kayser, and Margaret "Mikki" Squires. (Courtesy of Marie Heiner.)

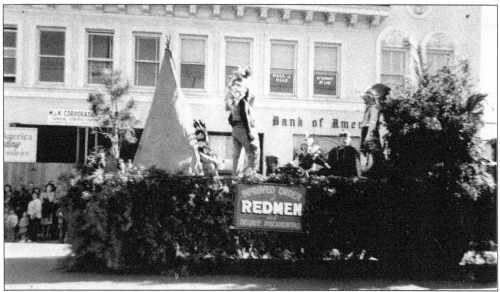

REDMEN FLOAT IN 1947 PARADE. The Order of Redmen, Navajo Tribe No. 115, a fraternal club, met every Tuesday in Redmen Hall, located on the second floor above the Bank of America at the corner of Franklin and Main Streets. The organization is shown in 1947 in one of Santa Clara's frequent parades. The Ladies of Pocahontas, Wanda Council No. 38, were an auxiliary group of the Redmen. (Courtesy of Lydia Corea to Bea Lichtenstein Collection.)

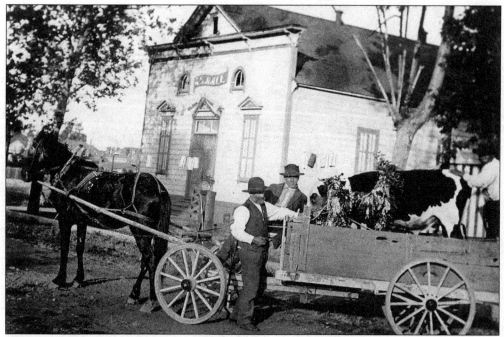

WAGON AT SES HALL. The Society of the Holy Spirit, a Portuguese fraternal organization, was founded in Santa Clara on December 16, 1895. The main activity was the annual *festa* which started on Saturday evening with the crowning of the Festa Queen. On Sunday, following a procession to St. Clare's Church, a huge barbecue, concert, and auction sale took place at SES Hall. Shown here is a cow being brought for the auction. (Courtesy of Santa Clara City Library, Leonard McKay's Clyde Arbuckle Collection.)

SHAKESPEARE CLUB. In 1895 members of the Shakespeare Club formed the Santa Clara Book Club. By 1901 the club had 300 volumes and a membership of 108. When the public library opened in 1903 in rented space on the second floor of the Franck Building, the book club gave their books to that collection. The club is pictured here at a meeting at the home of George Bray on Scott's Lane. (Courtesy of Santa Clara City Library, Leonard McKay's Clyde Arbuckle Collection.)

MARGARET OSBORNE. Margaret Osborne, wife of Dr. Antrim Edward Osborne, called the organizing meeting of the Santa Clara Woman's Club in 1904 and was one of the 11 charter members as well. Osborne served as president from 1904 to 1912 and then again from 1916 to 1935. (Courtesy of Santa Clara Woman's Club Archives.)

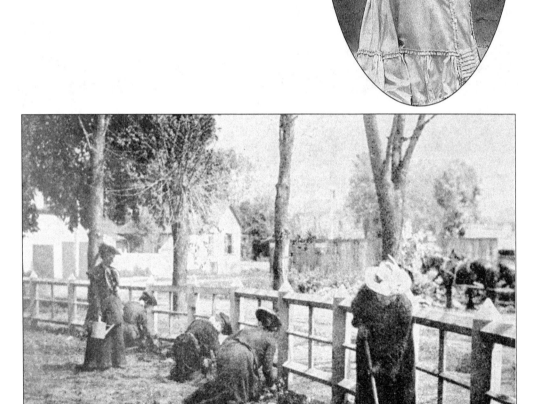

PLANTING GERANIUMS. The Woman's Club was first formed as a civic improvement society. Their first project was the long neglected City Plaza Park. A gardener was hired, weeds pulled, a lawn sown, and the bandstand painted. The ladies helped by planting red geraniums (their club flower) around the perimeter of the fence. Mrs. Osborne, on the far left, supervises the ladies in their endeavor. (Courtesy of Santa Clara Woman's Club Archives.)

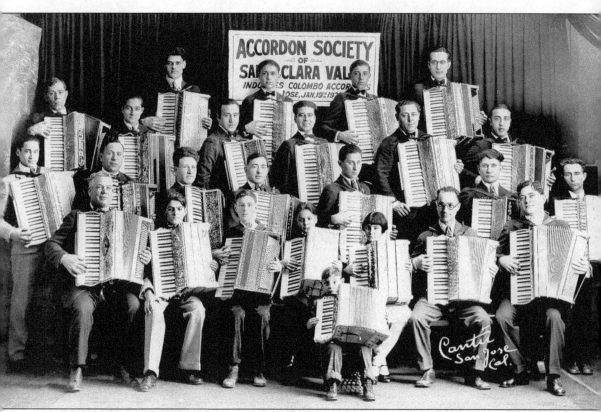

ACCORDION SOCIETY OF SANTA CLARA VALLEY. The Accordion Society, made up of fathers, sons, and one daughter, pose on January 19,1929. Alone in front is Tony Santilli. Other society members from left to right, are (front row) Frank Trena, Rocci Bengiveno, Frank Biceglia, Louie Santilli. Louie Santilli's daughter, and two unidentified men; (second row) Nick Triena, Rocci Armento, and two unidentified men; Anthony Abate, William Micali, and unidentified; (third row) Odino Bruno, unidentified, Joseph Pollizzi, unidentified, Nick Minori, and George Gregorio; (back row) unidentified, Frank Umbriacco, Mike Doglietto, and Louis Figone. (Courtesy of Santa Clara Historic Archives.)

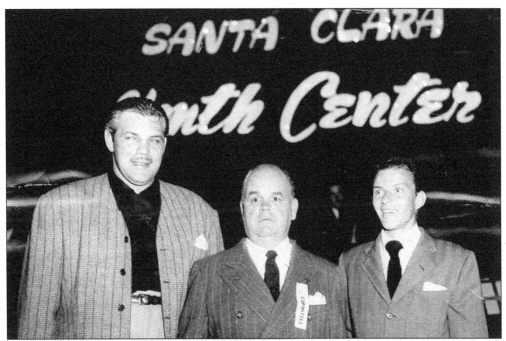

WATZIT CLUB/YOUTH VILLAGE. A youth club called The Watzit Club was created by Santa Clara students about 1945. Fr. Walter Schmidt, S.J. of Santa Clara University, was active in the club and arranged a benefit performance fundraiser for a new youth center. A group of Hollywood celebrities appeared at the sellout benefit on April 26, 1947. Buddy Baer (left) and Frank Sinatra (right) pose with Santa Clara Mayor James R. Bacigalupi. (Courtesy of Santa Clara Historic Archives.)

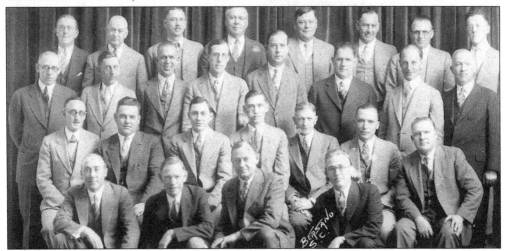

GREATER SANTA CLARA CLUB. The Greater Santa Club, made up of Santa Clara businessmen, from left to right, included (front row) Frank Vargas, Allie Sallows, Mike Kane, and Francis Scott; (second row) Bill Lotz, Walter Wahl, Dr. McGinnis, Bill Wilson, Ward Jarvis, John South, and Bertram Walker; (third row) George Pena, Iril Crowe, Earl Benson, Dick Synder, Judge Charles Thompson, Charlie Fitzwater, Al Nuttman, Mark Lavelle; and (back row) Frank Blake, Ben Fernish, Clem Lang, Charlie Robbins, August Roll, Louie Hanson, Jim Dowell, and Les Blake. (Courtesy of Margot (Blake) Warburton.)

SANTA CLARA CHAMBER OF COMMERCE. The predecessor of the Santa Clara Chamber of Commerce was the Santa Clara Commercial League, which existed until 1915. Early on, there was a close liaison between the chamber of commerce and city government, which continues today. Pictured, from left to right, are Tony Condos, president of the Santa Clara Chamber of Commerce; Owen Reeves, chairman of ICB; Charles Kinney, city councilman/rose float chairman; and Earl Carmichael, director of Parks and Recreation. (Courtesy of Santa Clara Chamber of Commerce.)

ROTARY CLUB OF SANTA CLARA PAST PRESIDENTS. The Santa Clara Rotary Club has been extremely active in Santa Clara since receiving its charter on August 10, 1936. Over the years, youth, civic, and cultural activities have all benefited from the club's benevolence. The club's past presidents, from left to right, include (front row) Phil Auger, Bob Gustke, Ron Dorst, Bill Nicholson, Dave Smith, and John Johns; (middle row) Larry Fargher, Gary Citti, George Delucchi, Neal Hoffman, Jack Hoffman, Dale Swanson, and Wendell Huxtable; (back row) Dick Brooding, Bob Buchser, John Nelson, Terry Carmody, Manny Ferguson, Bob Mortensen, Bob Suhr, and Lorenzo Rios. (Courtesy of Rotary Club of Santa Clara.)

OPTIMIST CLUB OF SANTA CLARA. The Optimist Club of Santa Clara was formed in July 1954. The main function of this service club is to act as a friend of youth in citizenship, recreation, and guidance. The club raises funds by selling ice cream at the city's July 4th picnic and at the annual Art & Wine Festival. Club members, from left to right, are Jim Watt, Jack Boyto, Vick Massone, Dolores Massone, George Gneri, Mike Mc Kenna, Al Faria, and Mary Beth Watt. (Courtesy of Optimist Club of Santa Clara.)

SANTA CLARA SISTER CITIES ASSOCIATION. The Santa Clara Sister Cities Association organized in November 1972. The first relationship was with Coimbra, Portugal, in 1972. Izumo, Japan, became Santa Clara's second sister city in 1986. Student exchanges are held annually between Santa Clara and Izumo, although there are less frequent visits with Coimbra. (Courtesy of City of Santa Clara Photograph Collection.)

SANTA CLARA HOST LIONS CLUB. Santa Clara Host Lions Club organized on May 16, 1947. During is first year, the club sponsored the Green Dragons Marching Band at the International Lions Convention and a float, shown here in the 1947 Columbus Day Parade. Present-day activities include sponsoring youth programs and support of groups for the blind. (Courtesy of Lydia Corea to Bea Lichtenstein Collection.)

CHERRY FESTIVAL PARADE. Santa Clarans have always loved parades. The first Cherry Festival began in 1913 to honor the cherry harvest in Santa Clara Valley and was conducted under the auspices of the Santa Clara Commercial League. The festival was held again June 2–6, 1914, for five days and nights of exhibits, concerts, dances, fireworks, and daily parades. This event attracted over 50,000 visitors, but was never held again. (Courtesy of City of Santa Clara Archives.)

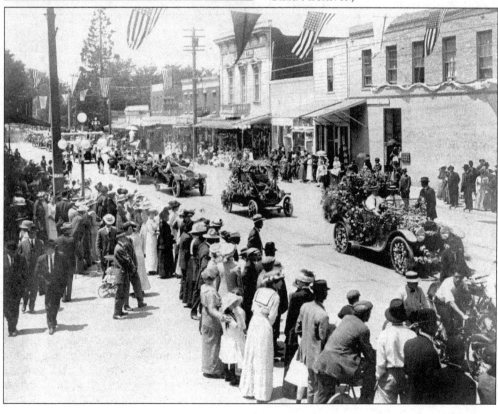

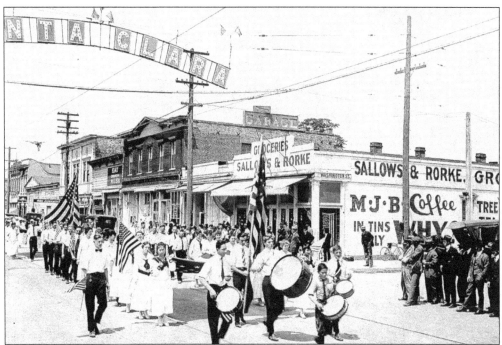

JULY 4, 1917, PARADE. Marchers in the July 4, 1917, parade pass under the lighted Santa Clara sign. The new sign, which spanned Franklin Street at the corner of Washington Street, was 36 feet long and weighed 900 pounds. It was lighted for the first time on April 15, 1916. The marchers are passing Odd Fellows Hall (on the left corner) and Allie Sallows Market (on the right corner). (Courtesy of Santa Clara Historic Archives.)

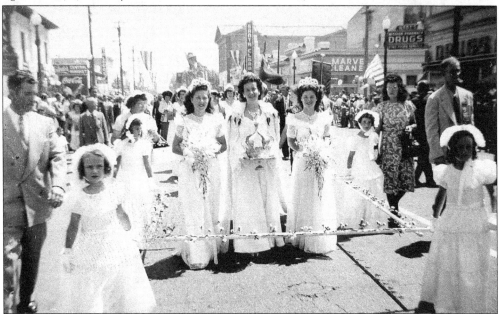

HOLY GHOST QUEEN AND PRINCESSES. The SES Holy Ghost Queen and her princesses march proudly down Franklin Street in the 1947 Columbus Day Parade. (Courtesy of Lydia Corea to Bea Lichtenstein Collection.)

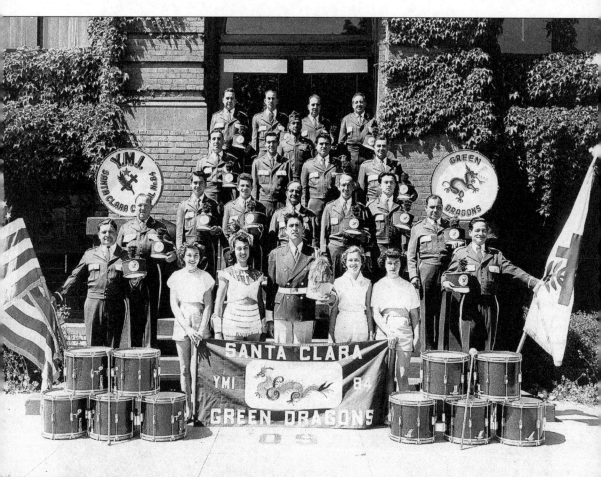

YMI Green Dragons Marching Band. The Young Men's Institute, Santa Clara Council No. 84, was organized in 1938. In 1945 the Santa Clara YMI formed the Green Dragons Marching Band, which competed in fiestas and parades and won state championships in1947, 1948, and 1949. Shown here, from left to right, are (first row) Pat Estecia, Pat George, Ed Cunha, Nadine Martin, and Beverly Santos; (second row) Tony Martin, Gus Imperto, Dave Bringuel, and Bill George; (third row) Gus Cunha, John Vierra, Clarence Gouveia, Richard Mattos, Gus Saverese, Mike Fuentes, Joe Souza, Manuel Freitas, and Freddie Cleveland; (back row) Larry Marsalli, Joe Seabury, Sam Sunseri, and Loren Pereira. Not pictured are corps members Les Kelii, Gerry Pereira, and Bud Kinkaid. (Courtesy of Cunha family.)

VANGUARD DRUM AND BUGLE CORPS. The Santa Clara Vanguard Drum and Bugle Corps, a non-profit organization, was formed in 1967. Vanguard maintains membership in Drum Corps International. The championship winning Vanguard was the first organization in DCI history to have two corps in the elite top 25. The Vanguard represented Santa Clara as an All-America City in the January 1, 2004 Tournament of Roses Parade. (Courtesy of City of Santa Clara Photograph Collection.)

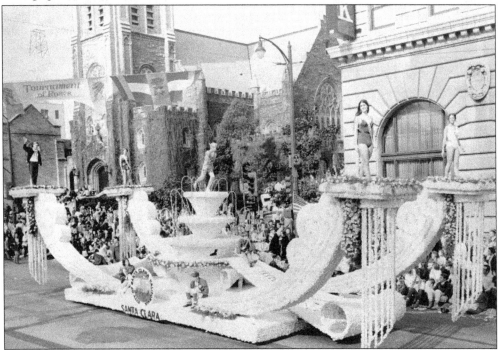

PASADENA ROSE PARADE. The City of Santa Clara entered a float with the theme "Through the Eyes of a Child" in the January 1, 1971 Pasadena Tournament of Roses Parade and won a top prize. The float represented Santa Clara as the youth sports capital of the world. (Courtesy of City of Santa Clara Photograph Collection.)

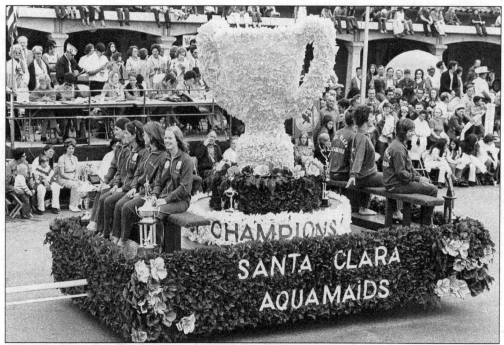

PARADE OF CHAMPIONS. The Parade of Champions evolved from the YMI Columbus Day Parade in 1945. The parade was a beloved city event for 50 years until finally being discontinued in 1995. Two YMI members, Larry Marsallit and Ed Cunha, were the guiding force behind this popular annual event. Shown on the float are the gold medal–winning synchronized swimming team. The Aquamaids train at Santa Clara's George Haines Swim Center. (Courtesy of Larry Marsalli.)

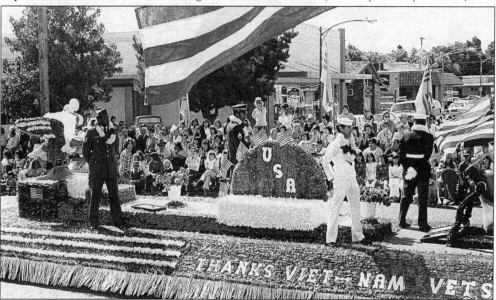

PARADE OF CHAMPIONS. Bands, drill teams, clowns, floats, horses, dignitaries in convertibles, and the Vanguard Drum and Bugle Corps were all components of the Parade of Champions. Vietnam War veterans are remembered in this float in the 1982 Parade of Champions. (Courtesy of Larry Marsalli.)

Seven

GROWTH AND CHANGE

NEW CIVIC CENTER. Santa Clara outgrew its 1913 city hall and built a new one with administrative offices and police facilities on a site outside the old downtown area. The new "civic center" at the corner of Lincoln Street and Warburton Avenue opened in 1963. (Courtesy of City of Santa Clara Photograph Collection.)

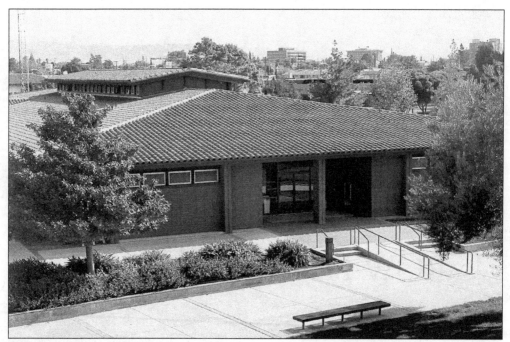

CIVIC CENTER POLICE BUILDING. The Santa Clara Police Department also outgrew its facilities in the 1913 city hall and moved to new facilities in Santa Clara's new civic center complex. The 1960s building was remodeled in the late 1970s. (Courtesy of City of Santa Clara Photograph Collection.)

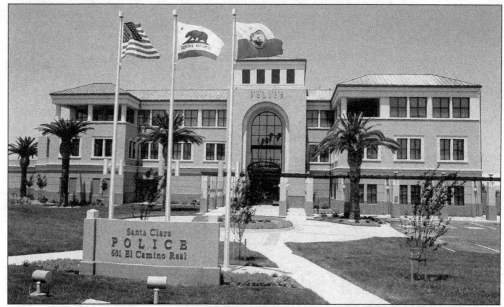

NEW POLICE HEADQUARTERS. By 1997 the Santa Clara Police Department had grown so much that its 1960s facility proved inadequate, prompting the city council to replace the 40-year-old building. The new facility, located the corner of El Camino Real and Benton Street near the historic train depot, was dedicated on October 21, 2000. (Courtesy of City of Santa Clara Photograph Collection.)

MISSION LIBRARY. In October 1955 the City of Santa Clara opened its first separate library building. Located in the old Plaza Park at Main and Lexington Streets, the new library cost $100,000 to build and had a shelf capacity of 30,000 books. (Courtesy of City of Santa Clara Photograph Collection.)

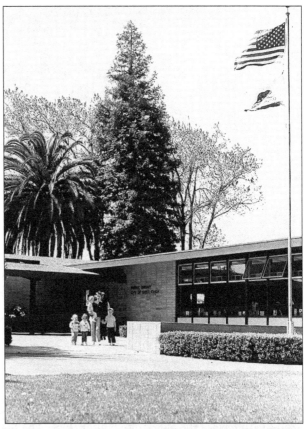

CENTRAL PARK LIBRARY. A second 36,000-square-foot library, built on Homestead Road by Central Park, opened on April 2, 1967, with a shelf capacity of 85,000 books. By the late 1970s, the Central Park Library required more room to handle rising circulation and the growth of its collections. After remodeling, the new 44,000-square-foot library reopened on September 7, 1980, with a shelf capacity of 250,000 books. (Courtesy of City of Santa Clara Photograph Collection.)

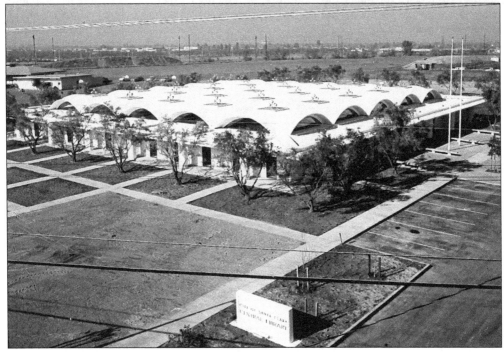

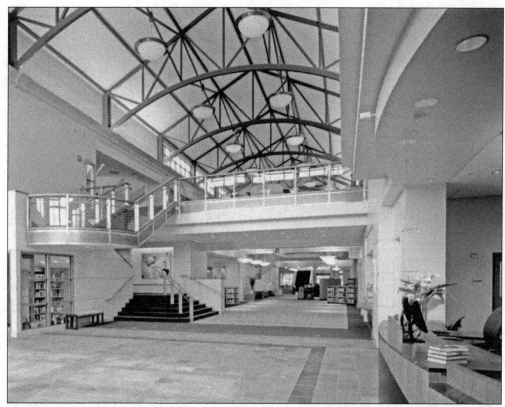

NEW CENTRAL PARK LIBRARY. A new 80,000-square-foot library has been built on Homestead Road site to replace the old facility built in 1967. The library had been relocated to temporary quarters on the old Curtis School site while construction took place. The beautiful, state-of-the-art library opened April 19, 2004, and provides many amenities, including 100 public access computers, views of Central Park and more services and programs for Santa Clara residents of all ages and interests. (Courtesy of City of Santa Clara Photograph Collection.)

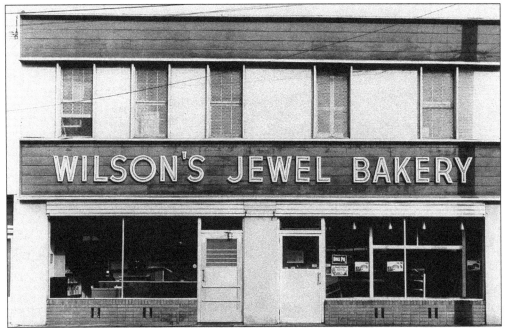

WILSON'S JEWEL BAKERY. William A. "Bill" Wilson bought the Jewel Bakery at 1151 Franklin Street in 1921 and named it Wilson's Jewel Bakery. The business prospered and gained a valley-wide reputation over the years. When the 1960s urban renewal project razed eight square blocks of downtown Santa Clara, Wilson's Jewel Bakery was among 13 original property owners who relocated to the Franklin Mall development. The bakery is now operated by Alex and Ken Wilson and their mother, Rosalie. (Courtesy of Wilson family.)

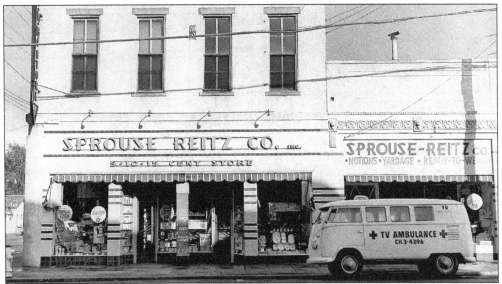

SPROUSE-REITZ COMPANY. The Casa Blanca Market operated by Louis Fatjo first occupied the space of the Sprouse-Reitz Store at 1095 Franklin Street. Louis Budde & Son's "Wonder Store for Ladies, Gents and Children's Wearing Apparel" occupied the space until the 1940s. The Sprouse-Reitz Store was the next tenant and occupied the space until the urban renewal project brought about its demise. (Courtesy of Margot Warburton.)

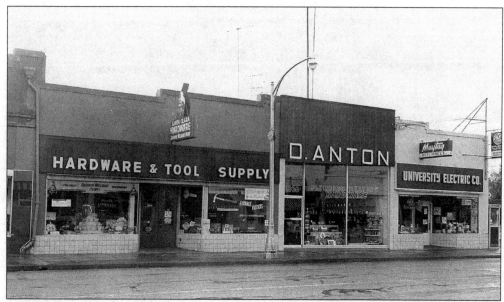

UNIVERSITY ELECTRIC. Jacob Heintz, the first graduate of Santa Clara University's electrical engineering school, opened the first electrical store in Santa Clara, naming it University Electric. The first store site was at 942 Main Street and then 1176 Franklin Street (shown here). Walter "Bud" Heintz took over the business when his father died after being hit by a car while visiting his native Germany. (Courtesy of Margot Warburton.)

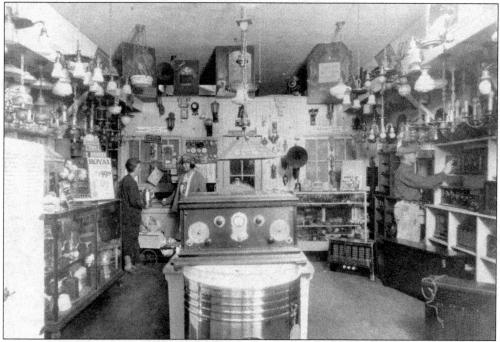

UNIVERSITY ELECTRIC INTERIOR. The interior of the 1176 Franklin Street store is shown in 1928. After being displaced by urban renewal in 1965, the business moved to 1391 Franklin Street. The final move for this family-owned-and-operated business came in 1993, when the store moved to its present location at 1500 Martin Avenue. (Courtesy of Heintz family.)

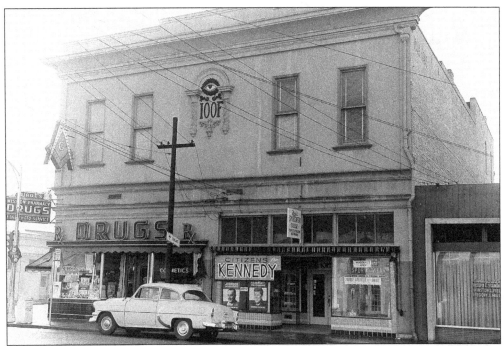

WADE'S PHARMACY/IOOF HALL. Walter Wade went to work at Ben Fernish's drugstore in 1927. In 1938 the Fernish family sold the business to Walter, who had to find a new location in 1944 and moved to the Odd Fellows building on the southwest corner of Franklin and Main Streets. Wade's Mission Pharmacy operated in that location until urban renewal forced him out. He then relocated to the two-square-block Franklin Mall development. (Courtesy of Margot Warburton.)

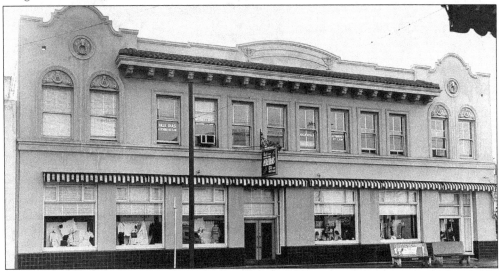

PEREIRA MEN'S STORE. Pereira Men's Store was originally the site of the Mission Bank, founded by Robert A. Fatjo. Mission Bank was sold to the Bank of Italy in 1917, which later became the Bank of America. When Bank of America moved to Monroe and Franklin Streets, the old Mission-style building became the home of Gilbert Pereira's Men's Store. Upstairs were law offices and the Hall of the Redmen fraternal organization. (Courtesy of Margot Warburton.)

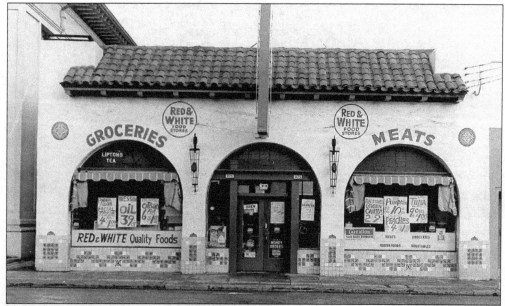

TOLEDO'S MARKET. The site of Toledo's Market first housed the Santa Clara Coffee Club, which opened on June 25, 1903. The Red and White Central Market opened at the site on August 22, 1919. Anthony Toledo went to work there in 1926, and when Frank Sallows died in 1928, Toledo bought the business and operated it under the name of Toledo's Red and White Market until 1963, when it was demolished for urban renewal. (Courtesy of Margot Warburton.)

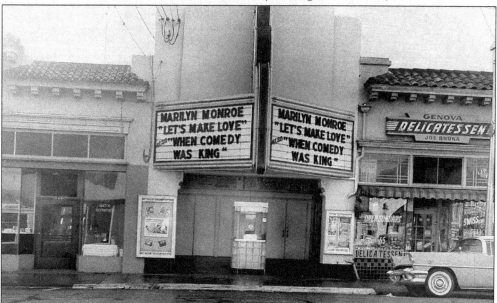

SANTA CLARA THEATER/GENOVA DELI. The Santa Clara Theater on Franklin Street began life about 1920 as the Casa Grande Theater. In the mid-1930s, the name changed to the Santa Clara Theater and many generations of Santa Clarans enjoyed movies there. Next door, the Genova Delicatessen, operated by Joe and Annita Bruna, was famed for its homemade raviolis. Both the theater and Genova Deli were put out of business by urban renewal. (Courtesy of Margot Warburton.)

PETERSON'S INSURANCE. Antone "Pete" Peterson came from Sweden in 1903 and, upon settling in Santa Clara, opened Peterson's Insurance Agency at 974 Main Street in 1929. On July 1, 1955, Joseph DeLozier became a partner in the business and worked with Peterson until Peterson's retirement in 1958. Peterson's became another business forced out by urban renewal in 1963. (Courtesy of Margot Warburton.)

DELOZIER GROUNDBREAKING. Peterson's Insurance Agency was the first tenant to relocate in the Franklin Mall at 1270 Benton Street in July 1966. Joseph and Joanne DeLozier are shown breaking ground at their new location. In 1975 David DeLozier became a partner with his parents and continues to manage the business today. (Courtesy of Joseph and Joanne DeLozier.)

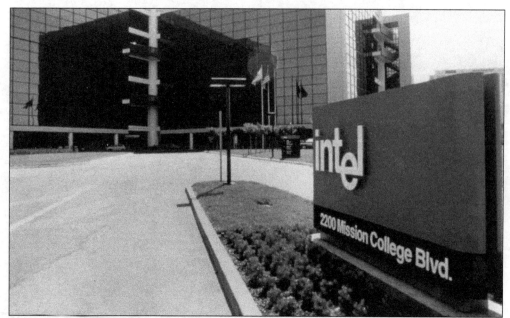

INTEL CORPORATION. Intel Corporation was founded by Robert Noyce and Gordon Moore in 1968. They were soon joined by Andrew Grove. Two of Intel's developments were critical to the growth of the computer industry: the microprocessor and large-scale memory. At its headquarters on Mission College Boulevard, Intel has built a museum to depict the history and development of the semiconductor industry. (Courtesy of Intel Corporation.)

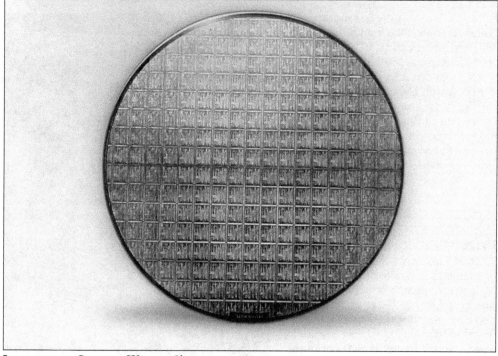

INTEGRATED CIRCUIT WAFER. Shown is a silicon wafer with integrated circuits. One wafer contains hundreds of integrated circuits. (Courtesy of Intel Corporation.)

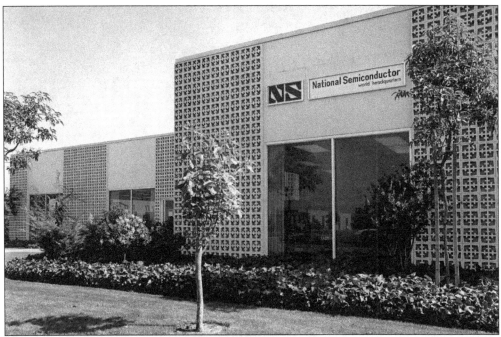

NATIONAL SEMICONDUCTOR BUILDING 1. National Semiconductor was founded in 1959 in Danbury, Connecticut. Headquarters were moved to Building 1 on San Ysidro Way in Santa Clara in 1967. The building was remodeled in 1999. National's Santa Clara campus is just west of Building 1 on Kifer Road. (Courtesy of National Semiconductor.)

NATIONAL SEMICONDUCTOR CAMPUS. The National Semiconductor Santa Clara campus, *c.* 1980, included two wafer fabrication facilities, engineering, marketing, and corporate offices. (Courtesy of National Semiconductor.)

PULLING WAFERS FROM FURNACES. A rack of four-inch wafers is pulled from a furnace in the mid-1980s. Furnace temperatures of about 1200 degrees Celsius (2192 degrees Fahrenheit) must be kept within one degree Celsius to ensure best results. (Courtesy of National Semiconductor.)

LM10 INTREGRATED CIRCUIT. The long-lived LM10 operational amplifier was developed by National's Bob Widlar in 1976 and is still manufactured today by National and other semiconductor companies. (Courtesy of National Semiconductor.)

Eight

ATTRACTIONS AND LANDMARKS

CONVENTION CENTER. To further encourage the tourism and entertainment trade, the City of Santa Clara built a new convention center on Tasman Road near Great America Theme Park. July 13, 1986, marked the grand opening of the convention center. The Santa Clara Chamber of Commerce and Convention/Visitors Bureau operates and manages the convention center for the city. (Courtesy of City of Santa Clara Photograph Collection.)

PARAMOUNT'S GREAT AMERICA.
Great America Theme Park was
built on city-owned land by the
Marriott Corporation and opened
during the U.S. bicentennial year in
1976. Paramount acquired the theme
park in 1994. The double-decker
Carousel Columbia, located at the
plaza entrance of Paramount's Great
America, stands 100 feet high and
features 103 carefully detailed figures.
Each figure is a replica of a famous
original. (Courtesy of City of Santa
Clara Photograph Collection.)

INTEL MUSEUM. The Intel Museum
has exhibits that include examples of
Intel products used in Internet and
communication systems. Also featured
are interactive exhibits on computer-
chip designs and history. Silicon wafer
fabrication requires "state-of-the-art"
clean rooms to prevent contamination
of the wafer chips by minute particles
of dust. Some young visitors are shown
here outfitted in clean room "bunny
suits." (Courtesy of Intel Corporation.)

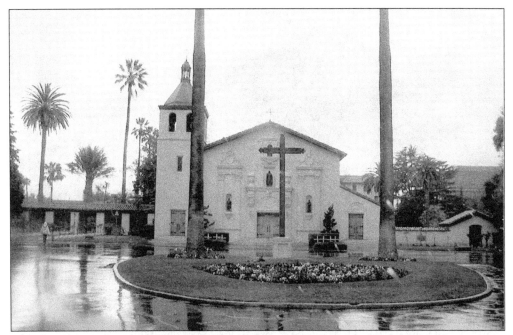

MISSION SANTA CLARA. The present structure on the University of Santa Clara campus is an enlarged replica of the original church built on this site in 1825. On January 12, 1777, a cross was placed at the first site on the banks of the Guadalupe River. Mission Santa Clara was the eighth of California's 21 missions. This state historical landmark serves as the church for Santa Clara University. (Courtesy of Mark Robinson.)

DESAISSET MUSEUM. Founded in 1955 through the bequest of Isabel deSaisset, the museum features rotating exhibits as well as permanent displays of art. The California Historic Collection features artifacts of pre-mission California Native Americans, relics from the original mission sites, and memorabilia from the days of the early college. (Courtesy of City of Santa Clara Photograph Collection.)

123

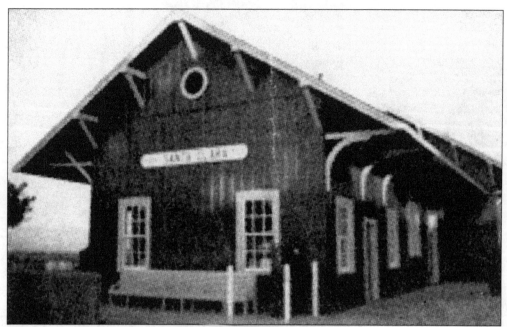

SANTA CLARA RAILROAD DEPOT. The Santa Clara Depot, built in 1864, was an original waystation on the San Francisco & San Jose Railroad line. Initially built on the east side of the tracks, the depot was moved in 1877 to its present location on the city side of the tracks. The structure was placed on the National Register of Historic Places on February 28, 1985, and restored by the South Bay Historical Railroad Society in 1986. (Courtesy of Edward Peterman, SBHRS.)

SANTA CLARA WOMAN'S CLUB ADOBE. The Santa Clara Woman's Club Adobe is a state-registered landmark and one of the oldest surviving adobe structures in Northern California. With origins dating to 1784, the Peña Adobe was part of a row of houses for married Native American couples associated with the third Mission Santa Clara. The adobe has served as the Woman's Club's headquarters and meeting place since 1914. (Courtesy of Santa Clara Woman's Club Archives.)

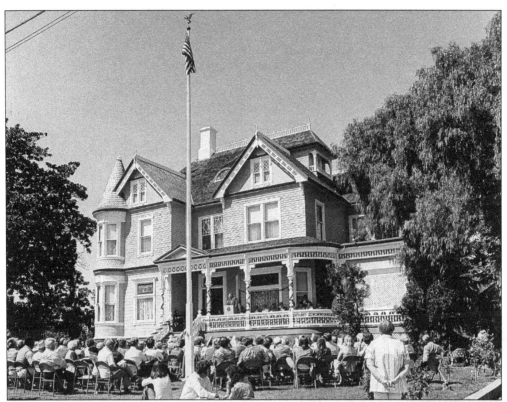

MORSE MANSION. "The house that seeds built" was constructed in 1892 by Charles C. Morse, co-founder of one of the largest vegetable and flower seed companies in the world, the Ferry-Morse Seed Company. This outstanding Queen Anne residence is the most elaborate in the City of Santa Clara. Shown here is the dedication ceremony denoting it as a state-registered historical landmark. The structure currently houses law offices. (Courtesy of Santa Clara Historic Archives.)

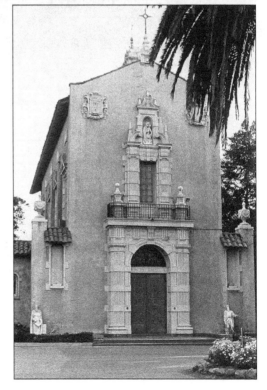

CARMELITE MONASTERY. This site is significant not only for its prize-winning architecture, but also due to its location on an historic ranch. Judge Hiram Bond purchased the site from James P. Pierce. Later, Bond's property was purchased for a new Carmelite monastery. On January 17, 1914, the Carmelite sisters arrived and took up residence in the old Bond house until they were able to move into the new monastery, dedicated on July 16, 1917. (Courtesy of Santa Clara Historic Archives.)

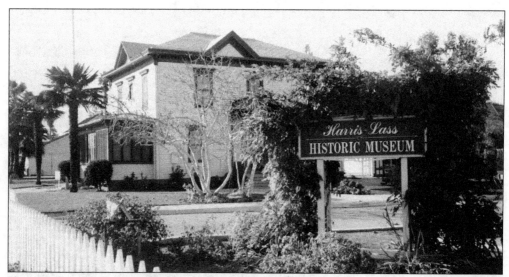

HARRIS-LASS HISTORIC MUSEUM. The Harris-Lass Historic Museum, located at 1889 Market Street, is the last preserved farm site in the City of Santa Clara. The property includes a large, fully furnished Italianate-style home, barn, summer kitchen, and a tank house. Named for the two families who owned it and lived there for 125 years, it is operated by the Historic Preservation Society of Santa Clara. (Courtesy of City of Santa Clara Historic Archives.)

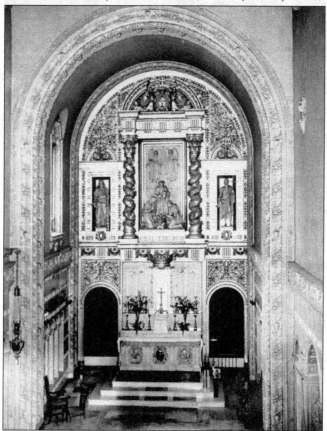

CARMELITE CHAPEL ALTAR. The Spanish Renaissance architectural style of the Carmelite Monastery is freely expressed in the ornamentation of the chapel. The altar in the sanctuary at the front of the chapel is rendered in Botticino marble with inlays of gilded carving and four bronze plaques symbolizing the four evangelists. One of the two sedilias on the sides of the sanctuary opens onto the Oratory of Our Lady where the nuns attend mass. (Courtesy of Santa Clara Historic Archives.)

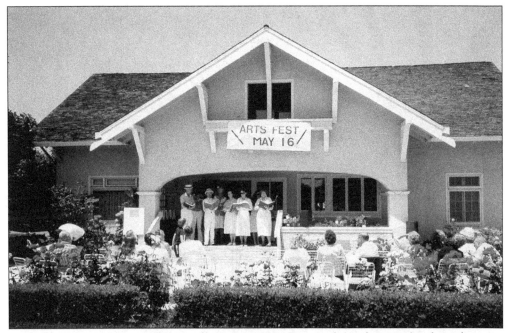

HEADEN-INMAN HOUSE. The Headen-Inman House, named for the two families who once owned it, includes a museum with photographs and artifacts related to the history of Santa Clara. The Santa Clara Founders and Pioneers Room has exhibits featuring the founding families and early pioneers of Santa Clara County. It is also the headquarters of the Santa Clara Arts & Historical Consortium, which operates the museum for the City of Santa Clara. (Courtesy of City of Santa Clara Photograph Collection.)

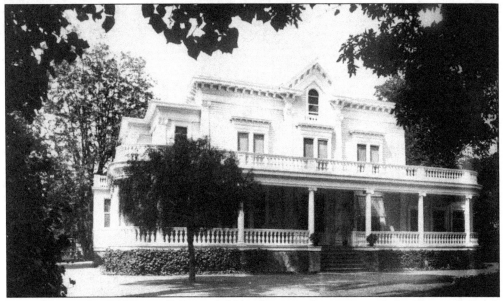

BOND HOUSE. In 1895 James P. Pierce sold his house and property to Judge Hiram G. Bond. During Bond's ownership, writer Jack London, a friend of the judge's sons Louis and Marshal, was a frequent visitor. It is believed that London used the Bond property as the starting locale for his novel *The Call of the Wild*. (Courtesy of Santa Clara Historic Archives.)

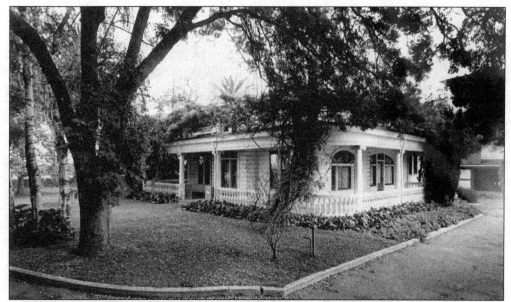

JAMISON-BROWN HOUSE. The Jamison-Brown house was originally located in the area now occupied by Great America. The house was built by Samuel I. Jamison in 1866 and later remodeled by its second owner, Alfred Brown. Included in the Brown remodel was the porch from the Bond home that was razed to make way for building the Carmelite Monastery. The Jamison-Brown house was moved to its present location, behind the Triton Museum, in 1971. (Courtesy of Santa Clara Historic Archives.)

TRITON MUSEUM OF ART. The present Triton Museum of Art opened in 1987 and serves to enhance the quality of life of people in Santa Clara and the Bay Area through a program of art, education and community involvement. The Austen Warburton Collection of Native American artifacts is a permanent exhibition. Rotating exhibitions of works from the museum's permanent collection and the work of local artists are regularly featured. (Courtesy of City of Santa Clara Photograph Collection.)

CPSIA information can be obtained
at www.ICGtesting.com
Printed in the USA
LVHW101322080419
613364LV00025B/322/P